The Art of Photographing
North American Birds

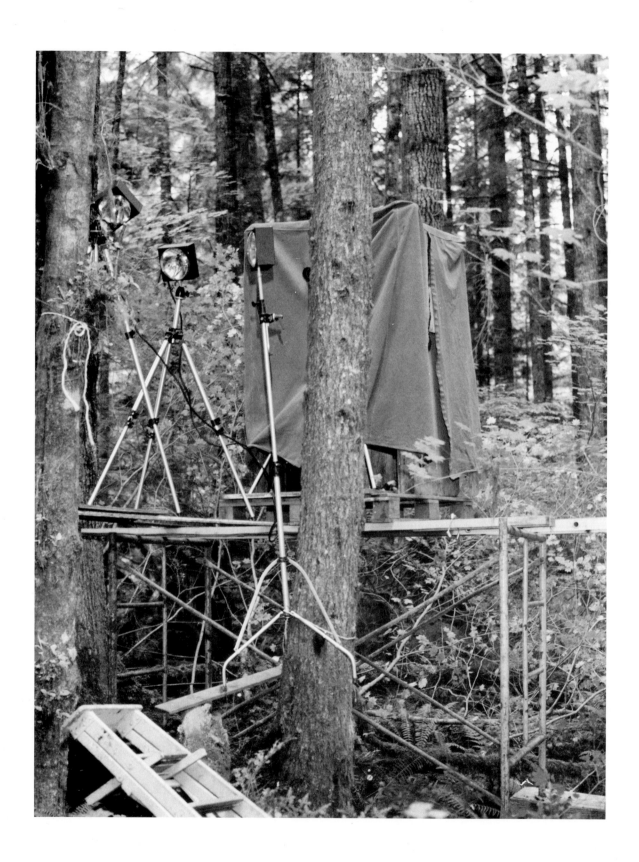

The Art of Photographing North American Birds

Isidor Jeklin & Donald E. Waite

Galahad Books · New York City

First published in the United States of America in 1986 by
Galahad Books
166 Fifth Avenue
New York, NY 10010

By arrangement with Donald E. Waite Photographer and
Publisher Co. Ltd.
Library of Congress Catalog Card Number: 86-80395
ISBN: 88365-706-6

Printed and bound by Graficromo s.a., Cordoba, Spain

Table of Contents

List of Plates

22 COMMON TERN Sterna hirundo 1976/IJ
23 NORTHERN HARRIER Circus cyaneus 1978/IJ
24 NORTHERN GOSHAWK Accipiter gentilis 1983/IJ
25 OSPREY Pandion haliaetus 1976/IJ
26 RING-NECKED PHEASANT Phasianus colchicus 1978/IJ
27 RUFFED GROUSE Bonasa umbellus 1982/IJ
28 AMERICAN KESTREL Falco sparverius 1976/IJ
29 ROCK DOVE Columba livia 1977/IJ
30 MOURNING DOVE Zenaida macroura 1977/IJ
31 BARRED OWL Strix varia 1974/IJ
32 GREAT HORNED OWL Bubo virginianus 1980/IJ
33 NORTHERN SAW-WHET OWL Aegolius acadicus 1977/IJ
34 EASTERN SCREECH-OWL Otus asio 1977/IJ
35 COMMON NIGHTHAWK Chordeiles minor 1978/IJ
36 BELTED KINGFISHER Ceryle alcyon 1980/DEW
37 RUBY-THROATED HUMMINGBIRD Archilochus colubris 1981/IJ
38 RUFOUS HUMMINGBIRD Selasphorus rufus 1983/DEW
39 DOWNY WOODPECKER Picoides pubescens 1983/IJ
40 RED-BREASTED SAPSUCKER Sphyrapicus ruber 1982/SP
41 NORTHERN FLICKER Colaptes auratus 1978/DEW
42 PILEATED WOODPECKER Dryocopus pileatus 1983/IJ
43 EASTERN KINGBIRD Tyrannus tyrannus 1978/IJ
44 EASTERN PHOEBE Sayornis phoebe 1975/IJ
45 WILLOW FLYCATCHER Empidonax traillii 1978/DEW
46 LEAST FLYCATCHER Empidonax minimus 1976/IJ
47 WESTERN FLYCATCHER Empidonax difficilis 1978/DEW
48 GREAT CRESTED FLYCATCHER Myiarchus crinitus 1982/IJ
49 BARN SWALLOW Hirundo rustica 1977/IJ
50 TREE SWALLOW Tachycineta bicolor 1981/IJ
51 BLACK-BILLED CUCKOO Coccyzus erythropthalmus 1978/IJ
52 BLUE JAY Cyanocitta cristata 1979/IJ
53 BLACK-CAPPED CHICKADEE Parus atricapillus 1982/IJ
54 RED-BREASTED NUTHATCH Sitta canadensis 1981/IJ
55 RED-WINGED BLACKBIRD Agelaius phoeniceus 1977/IJ
56 MARSH WREN Cistothorus palustris 1983/DEW
57 BEWICK'S WREN Thryomanes bewickii 1983/SP
58 DARK-EYED JUNCO Junco hyemalis 1981/IJ
59 AMERICAN DIPPER Cinclus mexicanus 1982/DEW
60 VARIED THRUSH Ixoreus naevius 1983/DEW
61 WOOD THRUSH Hylocichla mustelina 1978/IJ

62 VEERY Catharus fuscescens 1981/IJ
63 AMERICAN ROBIN Turdus migratorius 1983/SP
64 SWAINSON'S THRUSH Catharus ustulatus 1982/KSW
65 HERMIT THRUSH Catharus guttatus 1978/IJ
66 GRAY CATBIRD Dumetella carolinensis 1974/IJ
67 BROWN THRASHER Toxostoma rufum 1978/IJ
68 LOGGERHEAD SHRIKE Lanius ludovicianus 1977/IJ
69 CEDAR WAXWING Bombycilla cedrorum 1977/IJ
70 GOLDEN-CROWNED KINGLET Regulus satrapa 1982/DEW
71 EASTERN BLUEBIRD Sialia sialis 1980/IJ
72 RED-EYED VIREO Vireo olivaceus 1980/IJ
73 GOLDEN-WINGED WARBLER Vermivora chrysoptera 1982/IJ
74 WILSON'S WARBLER Wilsonia pusilla 1979/DEW
75 ORANGE-CROWNED WARBLER Vermivora celata 1983/DEW
76 CHESTNUT-SIDED WARBLER Dendroica pensylvanica 1980/IJ
77 RUFOUS-SIDED TOWHEE Pipilo erythrophthalmus 1983/SP
78 BROWN-HEADED COWBIRD Molothrus ater 1983/SP
79 COMMON YELLOWTHROAT Geothlypis trichas 1981/DEW
80 HORNED LARK Eremophila alpestris 1981/IJ
81 SONG SPARROW Melospiza melodia 1984/IJ
82 CHIPPING SPARROW Spizella passerina 1983/IJ
83 AMERICAN TREE SPARROW Spizella arborea 1982/IJ
84 FIELD SPARROW Spizella pusilla 1982/IJ
85 WHITE-THROATED SPARROW Zonotrichia albicollis 1982/IJ
86 ROSE-BREASTED GROSBEAK Pheucticus ludovicianus 1979/IJ
87 EASTERN MEADOWLARK Sturnella magna 1975/IJ
88 NORTHERN ORIOLE Icterus galbula 1974/IJ
89 HOUSE FINCH Carpodacus mexicanus 1977/DEW
90 PURPLE FINCH Carpodacus purpureus 1979/IJ
91 EVENING GROSBEAK Coccothraustes vespertinus 1979/IJ
92 AMERICAN GOLDFINCH Carduelis tristis 1981/DEW
93 COMMON REDPOLL Carduelis flammea 1980/IJ
94 NORTHERN CARDINAL Cardinalis cardinalis 1978/IJ

Foreword

By combining skill and knowledge with a unique quality of perception, an artist produces something interesting and pleasing. It may be a picture and, in fact, the word "artist" brings to mind that deft manipulator of brushes, the painter. However, some visual artists work not with paints and brushes but with cameras, and their pictures are photographs, not watercolors or oils. Though using different media and techniques, photographer and painter have one thing in common, the ability to see as beautiful things that to others are ordinary and the desire to share this vision with those who do not have it.

In the pages that follow are photographs of birds, pictures of exquisite sensitivity that capture their subjects with wonderful immediacy. They are among the finest of their kind and the images — a dipper with a wriggling, neatly held water insect or a hummingbird back-pedalling from a nectar-dropping columbine blossom — remain in the mind's eye long after the book is closed.

The saddest duty of photographs is to record what has gone. Here, in the pictures of Isidor Jeklin and Donald Waite, they have a happier task; that of showing us, evocatively and beautifully, what we have still.

As the unspoiled parts of the world shrink and ebb away, receding deeper into the dreamtime of the past, photographs such as these become more important. They renew our pleasures in wild things and serve to remind us that our vital link with the earth and its values must remain unbroken.

Victoria, B.C.
October, 1983. J. Fenwick Lansdowne

Introduction

When a customer walked into my camera store in Maple Ridge, B.C. in 1975, I had no idea that this chance meeting would result in a profound change in my life. He had just been hired by the provincial government to assist in the production of a book about the birds of British Columbia, and was leaving shortly for a month of birdwatching in the Okanagan Valley. He showed me several slides and I recall thinking that, with a little practice, I should be able to do as well at bird photography.

A few days later I discovered the nest of a Rufous Hummingbird in a large western redcedar in my own front yard. For the first time in my life I took the time to watch a male "hummer" go through a series of aerial manoeuvres in an attempt to win the favours of the chosen female. He would shoot straight up into the sky, sometimes out of sight, only to dive down again and pull up sharply in front of the female, who sat perched on a branch of the cedar. Suspended in mid-air he would 'twist and shout' his *dit-di-dit-dee* only inches away from the female, and when the sun's rays caught the iridescent crimson of his throat patch as he twisted left and right, he must have been irresistible to her — with the result that the next day the female could be seen gathering spiders' webs from the gable of our neighbor's house. Aware that she was nest building, I spent the following Sunday afternoon lying on a cot with binoculars, staring up into the huge cedar. It took three hours to find the nest, about the size of a 50 cent piece, and made mostly of cobweb and lichen, straddling a branch less than three meters (ten feet) off the ground. By the following weekend there were two tiny white eggs, later replaced by the young: featherless, black as coal, and about the size of two bees. For the first week the female alighted on the edge of the nest and fed by regurgitation, but once the two fledglings had begun to feather out, their mother fed them spiders for the protein required for bodybuilding, while she fed on nectar for quick energy. Hovering above the nest, she thrust her beak deep into the babies' throats, and any forward motion would have resulted in her spearing one of the young. Within ten to twelve days the fledglings were larger than their mother, and they overflowed the nest. During this time I set up my camera and began firing it by means of a twenty foot air release each time the female buzzed the nest. The results were embarrassingly poor, but by then the die had been cast; I was hooked on the art of bird photography.

By 1978 I was averaging forty hours per week in the forest during the months of April through July. It was during this trial and error period that I met Stan Pavlov, who remarked that he could find more nests in a day than I could possibly photograph in a week. Stan was managing an estate of 65 hectares (160 acres) nestled under the peaks of the Golden Ears Mountains north of Maple Ridge, British Columbia. I soon discovered the truth of his claim and have worked with him ever since. About the same time, I met Dorothy and Arthur Peake, long time bird watchers. Art had an extensive library of ornithology books which he was always willing to put at my disposal. By reading these books during the winter months, I learned about the habits of many species, so that I actually began finding the nests of some of the more secretive birds.

In 1980 I met well-known bird photographer Thomas J. Webb. His razor-sharp competition prints made me realize that I was not filling the frame tightly enough and that my flash equipment was just not capable of recording the quick movements of birds in flight. Tom suggested that I purchase a high-speed strobe being manufactured by A. Kenneth Olson, an electrical engineer and custom builder of photographic flash systems for 25 years. The purchase of this extremely powerful flash unit was a major breakthrough in my pursuit of photographing birds in flight. This unit was similar in many ways to the lighting system I used in my portrait studio, and I realized that my years of wedding and portrait photography were stepping stones to this new venture. Olson's strobe unit worked so well that the following spring I bought a photo-electric triggering device, which he also manufactured, and which permitted the subjects to take their own portraits by breaking a beam of light.

The following year I had a rare opportunity to visit Triangle Island, a seabird reserve located in the Pacific Ocean, 60 kilometers (40 miles) off the northern tip of Vancouver Island. In August I flew there by helicopter, accompanied by Richard J. Cannings, Assistant Curator of the Vertebrate Museum at the University of British Columbia, to spend a week photographing seabirds. We were greeted on arrival by Anne Vallée, who was collecting data for her Ph.D. thesis, "The Breeding Success of the Tufted Puffin", and her assistant Robin Cohen.

Triangle Island was breathtakingly beautiful, but it was also a harsh and hostile environment, where a misplaced step could mean certain death. In most places the ground was turf-like and dry, so that a rugged tripod could not give the necessary support for even a medium format camera. I was impressed with Anne's dedication and zeal in carrying out her research despite the difficult conditions, and I left the island determined to return someday with the equipment that could properly record its beauty.

Another major breakthrough in my search for knowledge about bird photography came when I read an article in an issue of Braun Canada *Photonews* about Isidor Jeklin of Don Mills, Ontario. I wrote to Isidor, and in 1982 met with him in Toronto. We soon developed a strong rapport, with the result that a partnership was struck to work together to produce a book on photographing birds. I learned that he, along with working partner Lawrence Parsons, had gone through trying times similar to my own while learning about bird photography.

Isidor's adventures with birds began in 1969, when he helped to erect a six meter (20 foot) T.V. antenna tower to be used as a huge camera tripod for bird

photography. The project intrigued him so much that he accompanied his friend on the next outing, which involved photography from a blind. The experience of watching birds at such close range, behaving naturally in their own environment, captivated Isidor and soon he had his own equipment. Isidor is a conservation-minded naturalist whose philosophy, like my own, dictates that every care be taken when photographing nesting birds, since nestlings are delicate, vulnerable creatures, whose natural habitat must be disturbed as little as possible.

Isidor and I both prefer to study a location close to home. Familiarity with the terrain, nesting habitats, and the species likely to be found in an area all contribute to successful photography. But on a few occasions our endeavors have led us further afield, and Isidor has travelled to the Everglades in Florida for southern species, the St. Mary's Islands in the Gulf of St. Lawrence for eastern seabirds, Bonaventure Island for Northern Gannet, and Machias Seal Island for Atlantic Puffin.

Although I have done the writing of this book, Isidor and I have worked closely on the selection of photographs, and his techniques and experiences are blended into the text.

Just after my return from Ontario, I learned that Anne Vallée had fallen from a cliff on Triangle Island and drowned only a few weeks before. She had returned to the island to complete her research, and while checking a nesting area on one of the cliff faces, had lost her footing and fallen into a tidal pool. Anne was keenly interested in the book project and it was understood that I would perhaps publish some of her seabird photographs. Her parents showed me some of her slides and they were excellent, allowing me to fulfill a promise; the Tufted Puffin photograph on page 54 was taken by Anne. I am dedicating this book to her.

I would like to thank my wife Carol, who enhanced many of my prints through touch-up, and also J. Fenwick Lansdowne, perhaps the finest bird artist living today, who has done us the honour of writing the Foreword. Ontario naturalist and wildlife photographer James M. Richards is to be thanked for kindly reviewing the manuscript, and his many helpful suggestions have served to enhance the present text. His valuable assistance is hereby acknowledged.

Stan Pavlov once asked me why I wanted to do this book. Isidor and I concur in our reasons: if we can show others the beauty of birds, they will appreciate and protect them and the environment, making a better world for all. My children have learned this already; they have a tender feeling toward all living things and would never knowingly cause suffering or injury. My oldest son Kevin, although only eight years old, has sat silently for hours in my blind observing birds, and the Swainson's Thrush on page 97 is one of his photographs. For me, this is the highest compliment to my teaching.

Equipment and Technique

It is the dream of all would-be wildlife photographers to produce material worthy of publication in such magazines as *International Wildlife, Audubon, Canadian Geographic, National Geographic,* and *Nature Canada.* To realize that dream, the correct camera equipment, knowledge of animal behavior, patience, and just plain good luck (seldom possible without the first three) are necessary prerequisites.

Bird photography, like any other type of photography, is a specialized field. Many professional wildlife photgraphers use the 35 mm single lens reflex camera because it is compact, light, and accepts a wide range of lenses and accessories. Both Isidor and I have chosen to use a medium format camera which produces a negative or transparency several times larger than any 35 mm system. Providing the lenses are of the same quality as the 35 mm systems, the negative — four to six times larger with the medium format camera — will produce a sharper photograph.

Whether to use negative film or slide film is a personal choice made by each photographer, as there are advantages and disadvantages to both. I have chosen to work with color negative film — originally Kodak Vericolor II Professional, and more recently Vericolor III Professional with ASA 100-125, while Isidor has worked almost exclusively with Kodak Ektachrome EPR positive, or slide, film with ASA 64. Negative film has wider latitude and is thus more forgiving with respect to exposure, and prints can be altered by burning in or dodging — methods I like to use in bird photography. While negative film has this advantage, it is generally felt that transparencies reproduce better than prints for publication, since the separations are made directly from the film, without the intermediate step of the print. In my view, both are excellent, since both Vericolor III Professional negative and Ektachrome EPR transparency are medium grain films. A fine to medium grain film is most desirable for bird photography, since it yields better detail than a coarse grain film.

Most bird photography requires a small lens opening for the maximum depth of field, as well as a short shutter speed, to freeze the movements of the subject, necessitating the use of a flash unit. Light from the sun alone is seldom adequate, and when it is, the contrast between the areas in direct sunlight and those in

shadow is so high that quality printing is rarely possible. The only way to achieve top results is with an exceptionally powerful strobe system used with a compatible camera system. When I began photographing birds, I used a Hasselblad CM body with a normal 2.8/80 mm Planar lens, in conjunction with a Braun F-700 flash unit equipped with two heads. In order to get close to my subjects, I used close-up lenses or proxars which screwed into the front of the lens. It did not take long to discover that this camera, despite some disadvantages, had two outstanding features not found on 35 mm cameras. One was the large format — 6 cm × 6 cm (2¼ × 2¼ inches) as opposed to the 24 mm × 36 mm (1 × 1½ inches) found on the 35 mm systems, and the other was the leaf shutter in the lens rather than in the camera body, which permits flash synchronization up to 1/500 second.

On site, I placed the camera on a tripod slightly less than one meter (three feet) from the nest, with the two flash heads on either side of it also mounted on tripods, or sometimes tied by a rope to a branch. In order to prefocus the camera, I placed a roll of film in the nest, where the bird's head would be at the moment of exposure, and carefully focused on the fine detail of the print. Before leaving, I always checked to insure that the camera was loaded with film, cocked, set on X-synchronization for the flash, set at 1/500 second at f-16 or f-22, depending on the color of the bird, and — very important — that the film roll was removed from the nest.

Because the Braun F-700 is extremely powerful and kicks out a great deal of light, the photographer can use a very small lens opening for maximum depth of field, but there is another advantage as well. Since light diminishes in proportion to the square of the distance, these lights, when placed further back from the subject, tend to illuminate the background as well, rather than allowing it to fall off into darkness because the available light is not recorded. In some instances even more light was required, and then I placed independent strobes, hooked up to a slave unit, behind the bird. The slave unit is a small, cordless electric device which is light sensitive; any increase in light will cause an electronic switch to close, which will in turn fire the strobes. Thus, when the flash unit attached to the camera fires, the light will trigger the slave unit. I have used as many as five strobes to illuminate a scene.

For the 1976 season I worked with the manual Hasselblad CM body with a twenty foot pneumatic tubing or air release. This meant that after each exposure I had to emerge from a tent-like canvas blind to recock the camera. To carry on in this fashion would have required several lifetimes to acquire even a partial portfolio, and it placed severe stress on the birds. The following spring, I bought a Hasselblad EL/M (electric motor drive) camera body, a Variogon 5.6/140-280 mm macro zoom, and a 30 meter (100 foot) electric cable release. Now I could work from a blind from a distance of over 30 meters from the nest and camera, keeping everything under observation with a spotting scope. I could also take twelve exposures without approaching the camera. But before the season was over, I realized that for the type of photography I wanted to do, the duration of the flash from the Braun F-700 was far too long to stop the quick flight movements of adult birds. For the time being I would have to be satisfied with photographing stationary birds.

This problem was solved with the purchase of the extremely powerful Olson Strobe Unit consisting of three heads all synchronized to fire at 1/20,000 second — fast enough to freeze even the wing movements of a hummingbird. High speed flash was not the only advantage of this unit. Operated by five Everready #497 dry cell batteries, it recycles in two to three seconds, and with proper maintenance one set of batteries could be made to last as long as three years. Since low humidity and heat cause the batteries to dry and end their life prematurely, it was important that the complete battery chassis be encased in two plastic bags, one inside the other to retain moisture, and refrigerated at (3°C) 35°F. or lower during winter months. Other power sources are available for this equipment, such as rechargeable batteries. I chose 497s to avoid the inconvenience and problems associated with rechargeables. Olson also has under development and field testing a lightweight, smaller system capable of firing at 1/10,000 second, which does a good job of stopping even a hummingbird's wings.

The light from the Olson Strobe Unit is almost identical to the one used in my portrait studio. The umbrella-like, soft, wrap-around lighting virtually eliminated the harsh contrast obtained with my original flash. Two of the lights, called the main and fill, were placed on tripods just under and just over one meter (2 and 2½ feet) from the subject. Instead of placing both lights at 45 degrees to the camera I began using the system that I used in my studio. I placed the main light, or the one nearest the subject, at between 60 and 75 degrees to the camera, and in such a position that it would throw any shadow from the bird's beak behind its head. To soften the shadows, the second light, or fill, was placed on the opposite side of the camera. The third light, called the hair light by studio photographers, was mounted behind the subject and somewhat closer than the other two lights. The third light gave excellent separation and provided an aureole of light which outlined the birds' feathers with a halo of rim lighting. The hair light was often equipped with black cardboard shades, termed barn doors, which minimized the chance of unwanted light spilling into the camera lens.

Olson's high speed flash worked so well that I subsequently purchased his photo-electric triggering device. This unit, when plugged into the Hasselblad EL/M body, fires the camera each time the adult bird breaks a beam of light. The light source comes from an ordinary flashlight which has been modified so that it projects a pencil beam of light onto the triggering device. Whenever the beam is broken, the electric eye delivers a firing signal to the Hasselblad less than 1/1,000 second later; but the Hasselblad, or any camera for that matter, takes time to get going. It takes the Hasselblad .03 second to begin to operate, and during this time a small bird aproaching a landing will travel about 5 centimeters (2 inches). As a result the camera is focused 5 centimeters past where the bird breaks the beam. One of the great advantages of the Hasselblad system is the Polaroid back accessory. By making a Polaroid image the photographer can immediately confirm that he is getting the subject in the frame. It was also designed with a delay system which could be set anywhere from three seconds — the time required for the flash unit to recharge — up to thirty seconds. Set at the three to five second delay, the camera would usually record a second or third photograph of the adult

feeding the young; set at thirty seconds, it usually resulted only in shots of the adult arriving at the nest. It also had an override, which permitted the photographer to short-circuit the system and take over the firing of the camera.

I now use two cameras for bird photography: the Hasselblad EL/M body with the 4/150 mm Sonnar lens and the 10 mm, 21 mm, or 55 mm extension tubes instead of the cumbersome and heavy zoom; and the Pentax 6 cm × 7 cm (2¼ inches × 2¾ inches) equipped with automatic extension tubes 1, 2, or 3 on the 4/200 mm Super multi-coated Takumar lens. Most long lenses only focus down to three to 3½ meters (ten or twelve feet), while still taking in an area .6 meter (two feet) wide. I found that extension tubes (merely spacers that are inserted between the camera body and the lens) shortened the working distance between the camera and the subject. The smaller tubes allow the photographer to get in slightly closer with the camera and the bigger tubes permit him to get in close enough to fill the frame completely with something as small as a wren or a hummingbird. The leaf shutter in the Hasselblad lens permits photography at 1/500 second at f-16 or f-22 with flash in brightly lit areas, without any flight blur due to extraneous light. In low light situations, I use the Pentax 6 × 7 at 1/30 second at the smaller f-stops. The viewing screen of the Pentax is extremely bright, permitting faster and more critical focusing, and the fully useable negative is considerably larger than the useable portion of the square Hasselblad negative. With the 200 mm lens it is synchronized to fire with flash at 1/30 second and can be used only in low light situations, so that the light from the sun is not exposed on the film and flight blur is not recorded.

The equipment needed for bird photography is not limited to cameras and flash units. Tripods, scaffolding, binoculars, spotting scopes, notepads, clothing, and a host of other accessories all play important roles in the challenge. I now use a rugged Majestic tripod, capable of being extended 2.5 meters (8 feet), as a base for my camera, and three Italian-made Manfrotto light-weight tripods for the flash heads. Another extremely useful device, called a tripod clamp, can be fastened onto a tree limb or screwed into the tree, and a flash head affixed to it. As time goes on, a suitcase is required just to carry these extra gadgets.

Before the tripods are ever introduced into the forest I take the extra time to secure the rubber tips on the end of each leg with electrician's tape so they are not lost the first time the tripod is set up in the mud.

My original blind consisted of a piece of canvas which was fashioned into a makeshift blind on the site. The next step was a 1.2 × 1.2 × 1.5 meter (4 × 4 × 5 foot) blind made from thin plywood, which could be folded down, accordion fashion, for easy transportation. It came complete with a hinged back door, peepholes on all four sides, and a roof, and was painted camouflage green. Later I had a tenting company build a blind from a heavy khaki canvas with two-way rust proof zippers and velcro slits for peephole openings, which was designed to fit over a frame of aluminum tubing. Both these blinds were used some distance from the subjects, and observations were carried out with a spotting scope.

When systems work well, it sometimes requires a push to change. One day I decided to set up the blind only one meter (three to four feet) away from a nest. It

worked surprisingly well, and I have used this system since. I now set up my camouflaged blind about a meter from the nests of the smaller perching birds, and conceal myself in the blind with the camera mounted on a tripod and prefocused on the young. The critical focusing is left until the adult arrives at the nest. I always attempt to focus on the parent's eye just prior to firing the camera.

The adult birds usually approach the nest along a consistent route, and some time spent watching before positioning the equipment usually reveals this path. With smaller birds, I like to wait until the young are at least 5 or 6 days old; the interaction of parents and young is then most interesting, and the parents are less likely to desert at this stage of development. Results show that the more days I work a nest, the better are the photographs. Usually the best material is taken on the last day.

Improvising is a way of life for the nature photographer, and during my first two years I used stepladders onto which I roped tripods and flash units. When a seven meter (25 foot) high nest proved to be too high for the ladder to reach, I rented four sections of construction scaffolding. Made from five centimeter (2 inch) steel tubing, the scaffolding had only one major disadvantage, and that was its weight. Its major advantage was the large 1½ by 3 meter (5 by 10 foot) platform. Leaning a 6 meter (20 foot) stepladder against it, I could climb up and down with ease, and in no time was able to set up the blind, camera, and strobes at the nest. It worked so well that I bought it.

Isidor uses a system similar to mine, for the most part, but instead of the 4/150 mm Sonnar lens on the Hasselblad, he usually opts for the longer 5.6/250 Sonnar lens coupled with one or more extension tubes. On a few occasions, he has used two Hasselblad EL/M cameras on the same subject, one fitted with the 150 mm lens, and the other with the 250 mm lens. Synchronized to fire in unison, this system can be used to obtain good image size of the bird both at the nest and in flight.

When speed is not critical, Isidor uses modern equipment, but for high speed photography he uses a very old but powerful Multiblitz 111b flash unit, with two heads that fire at about 1/5,000 second. The unit was made in West Germany, is of post World War II vintage and, like other devices of that age, is very cumbersome and lacks some of the advantages of modern flash units. It is moisture sensitive, so extreme care must be taken to protect it in the forest. The unit came with amplifiers which could double or quadruple the light output, but they have the disadvantage of increasing the light duration, and Isidor prefers to work without them.

A quality scaffold is being manufactured and sold now by the Kern Company, in Ontario. Bruno Kern, who has had many years of experience in aluminum scaffold construction, has designed a lightweight, portable scaffold and blind. Used and tested for several years by noted bird photographer James M. Richards, the tower and blind have gone through a number of slight modifications to improve all safety factors and ease of on-site erection. The Kerncraft Tower consists of a base unit and seven sets of 1.8 meter (six foot) extensions for a total height of 14.4 meters (48 feet). Constructed from 3.75 centimeter (1½ inch) tubular, rustproof aluminum, the complete unit weighs less than 72 kilograms

(160 pounds) and can be carried in its entirety by two men using four of the braces as arms. Likewise, one man can carry a 7.2 meter (24 foot) 36 kilogram (80 pound) assembly alone. It was designed with rigid safety standards to withstand heavy stress factors and load requirements. The sections fit together on sleeves with stainless steel pins designed to lock in place. Each separate section comes with reinforced braces. Guy ropes can be installed to tie the tower on all four corners to nearby trees. Two men can erect the tower in less than one hour, which results in a great reduction in disturbance to the birds.

People often ask how the birds react to all this equipment. Birds, like people, have their own idiosynchrosies, and some birds will not tolerate the presence of a photographer and the equipment, while others of the same species carry on perfectly normally after a short period of adjustment. To work in such close proximity to a nest requires careful study, and if the adult birds are unwilling to accept the blind, lights, and camera, the project must either be abandoned or started afresh, but from a distance. In most instances, birds are extremely adaptable, and, once they become accustomed to the photographer, are very trusting.

It is important to realize that, although much time is spent in actually doing the photography, the photographer must be prepared to spend many hours in observation, both before and during the shoot. Isidor takes anywhere from three to twenty days to photograph a single nesting situation. A person who spends this much time and effort in the outdoors, closely observing creatures in the wild, is not likely to damage the environment or leave debris about, but this point cannot be emphasized too strongly. Raccoons, weasels, squirrels, rats, mice, and birds of other species might find and destroy a nest as a result of the photographer's activities. For this reason, tiebacks, ropes, or anything else which might attract the attention of a predator must be removed at the finish of a shooting session.

Recent rapid gains in the field of electronics have opened new doors for the outdoor photographer. I have just purchased a Dan Gibson electric parabolic microphone, with which I hope to record the vocalization of breeding birds, and by playing back their own song, bring them into camera range. With all the video equipment now on the market, it is possible that before long a photographer will be able to monitor birds on a television screen and fire the camera by remote control whenever the bird strikes the desired pose. While this might not appeal to the photographer who is also an outdoor enthusiast, it is undoubtedly true that the future holds many new and exciting possibilities.

<div align="center">* * * * *</div>

About two days after I met Stan Pavlov I drove up to the Blaney Creek Ranch in Maple Ridge, B.C., to see for myself if it was alive with birds as he claimed. Stan invited me into his rustic, ranch-style cedar shake home, nestled amongst the western hemlock and redcedar, and bigleaf maple. The view from the window of the house overlooked the sloughs of the North and South Alouette Rivers, while behind were the University of British Columbia's Research Forest and the lofty 1,700 meter (5,600 foot) high summits of the Golden Ears Mountains, part of the Coast Range. Although it was already July and the nesting season was almost

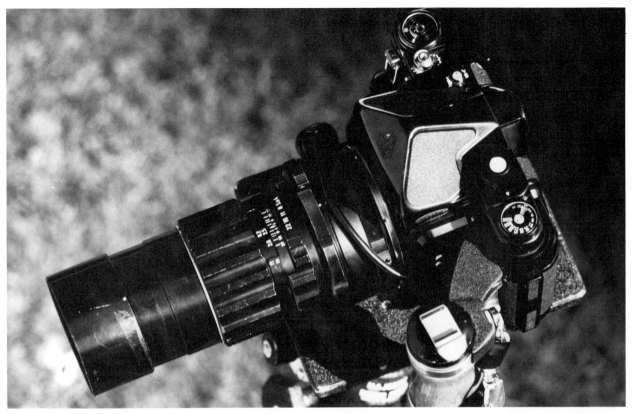

Waite's Pentax 6 cm × 7 cm equipped with the number 2 automatic extension tube and the 4/200 Super multi-coated Takumar lens.

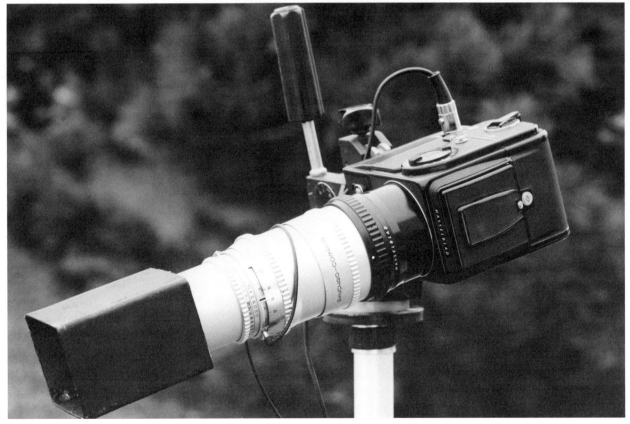

Jeklin's Hasselblad 6 cm × 6 cm EL/M (electric motor drive) equipped with the 55 mm extension tube and the 5.6/250 mm Sonnar lens.

over, Stan said he would be able to show me a Common Nighthawk nest on the hydro cutline, and soon we were trudging along an access road, two of the field glass fraternity. As we came out under the hydro line, I heard a booming sound which I had often heard before but never identified. Stan pointed to a nighthawk; it climbed into the sky, brought its wings into a tuck position and dived straight toward the earth, only pulling out at the last moment and ascending into a steep climb. The loud boom is caused by the positioning of the wings as the bird pulls out of the dive. As it crossed back and forth through the sky in search of mosquitos, its nasal *pneet* could be heard several times a minute.

By walking a grid pattern, we found the nest Stan had discovered a few days earlier and flushed the female. This time, instead of two eggs, there were two fawn-colored, bug-eyed nestlings. Before leaving I was already planning just how I could photograph this nest.

We did not return home the way we had come, but instead we dropped into a stand of mature cedar and hemlock. Just before arriving back at the house we passed beside a freshwater slough where I spotted several species of waterfowl, and it occurred to me that the house was located at the crossroads of several habitats, and that on our two hour outing I had seen Swainson's and Varied Thrushes, Black-capped and Chestnut-backed Chickadees, Golden-crowned Kinglets, Winter Wrens, American Dippers, Steller's Jays, Belted Kingfishers, plus other common birds indigenous to the area.

The next morning was overcast and cool but I decided to set up my photographic equipment anyway. I placed the manual Hasselblad with the 150 mm lens and the Braun F-700 flash heads on three tripods and ran a twenty foot air release to a canvas blind which I had improvised from tree poles tied together Indian teepee fashion. Concealing myself inside, I began my vigil, watching the babies through a tiny peephole.

For some reason I expected the birds to come into the nest by dropping straight out of the sky. Instead, I saw one of the nondescript brown and black adults waddling towards the nest through the salal. Just before she reached her young, they rushed to meet her and all the feeding took place behind a stump and out of my field of vision. When the bird flew off I emerged from the blind to reset the camera. In less than two hours the adult birds became so tame that before I was back in the blind from resetting the camera, they would be back tending to their babies. Over the next few days I would allow the female to brood for as long as an hour before I took any photographs. On several occasions I observed one of the parents resting on a burned windfall. Perched sideways, or parallel to the log, the bird was camouflaged so well that it appeared to be the proverbial bump on a log. When it began to rain I took the role of surrogate mother, cupping the two fuzz-balls in my hands, and exhaling warm air onto them — only to have one jump in my mouth. At the end of the fifth day the young had matured to the point where they began to move off into the vegetation, making photography difficult. I was generally pleased with the results, except that I photographed an area two feet square when all the activity happened within a one foot square arena. However, after cropping the negative, I could tell that I had a parent nighthawk and her two chicks.

The ranch proved to be a rich source of material for my camera. Two of the more common species that I discovered along the creek were the American Dipper, and the Winter Wren. The first nest I ever found in my wanderings up and down the creek was of this tiny wren. I found it in the root-tangles of a western hemlock that had been upended and fallen into the creek. I had been slowly working my way upstream when something scurried across the ravine and dropped into the earth cavity left by the fallen giant. I thought it was a mouse, but moments later it flew out from the tree's root system and I recognized it as a Winter Wren. On hands and knees I examined the roots for a nest; finding nothing, I retreated into an undercut in the embankment to watch. A short time later the wren reappeared, holding a spider in its beak, and began moving from limb to limb, all the time scolding hoarsely, before suddenly disappearing into the tree roots. This time I found its tiny ball of a nest, made almost entirely of mosses, lined with feathers, and containing six newly hatched young. I later discovered a second nest within two feet of the active one, but which was not lined with feathers, and near by two more long-abandoned nests. Their location was so difficult to photograph that I passed them by.

The dipper is one of the many birds to take full advantage of the seasonal abundance of food on Blaney Creek. Each year, near the end of April, peamouth chub ascend the creek as far as the falls to spawn. Over a four day period, the creek is choked with spawning fish, and then, as quickly as they appeared, the chub disappear down the creek. Their eggs, encased in a sticky substance, stick to the creek bottom to a depth of one to three inches. I have often watched in amazement as dippers, standing chest deep in peamouth chub eggs, gorged themselves until they were almost unable to fly. The same month, thousands of chum salmon fry are released by the Fisheries Department from the hatchery's holding tanks, located less than half a mile above the falls. It is little wonder that the dippers often choose to build their nests along the creek.

Appearing almost tail-less, and slate gray in color, this plump, robin-sized bird of the fast flowing creeks has the characteristic habit of continually bobbing up and down while resting. Capable of walking underwater, the bird has a nictitating eyelid, similar to goggles worn by a skin diver. As a protection against cold water, it has a secondary coat of oily down, making it unique among land birds.

* * * * *

The years 1976 through 1980 could be categorized as expensive learning experiences and the best advice I could ever give anyone breaking into the field of bird photography would be to apprentice with someone who has "been through the ropes". During those four years I spent considerably more time setting up and tearing down my equipment than actually taking photographs. My initial aim was for quantity, not quality, and one day I prided myself on having photographed three different species in a single day.

Bird photography is not without its failure and misadventures, and my experience working the nest of a Belted Kingfisher is a case in point. I had pushed a stick, to be used as a perch, into the gravel embankment close to the tunnel entrance to the nest, but all my attempts to get the bird to land on the perch were

in vain. It landed on the stepladder, the ground, a tree, and eventually even attempted a landing on the zoom lens mounted on the camera body. The rattling call could be heard for a mile or more when the bird failed to grasp a footing on the polished black surface. Finally, after almost eight hours, the kingfisher landed on the perch where the camera was prefocused. When I got the film back from the lab the shot was out of focus. The bird, in attempting the landing on the lens, had rotated the focusing ring!

One incident during those early years almost ended in disaster. Stan had discovered the nest of a Northern Harrier with three chicks, but to reach it, we had to cross three creeks in chest waders, and then chop our way through acres of hardhack with machetes. It took several hours to make a trail through this thick entanglement of vegetation, and it was late afternoon before we were set up. Stan left after I entered the blind. Almost immediately, the bird dropped down to the nest and I got a shot of it with wings spread as it landed beside the chicks. After I reset the Hasselblad CM camera, I re-entered the blind. Much to my disgust no further opportunities presented themselves. At that time I didn't realize that a second person, called a "goawayster" or decoy, had to walk away from the area in order to trick the bird of prey into thinking that no one was left near the nest.

When I packed up to leave, the sun had started to go down and I realized that another unexpected problem had come up — literally. One of the creeks was tidal, and was now at least a foot deeper than when I had crossed it earlier. With hands extended skyward, one holding a camera, the other my flash unit, I slowly and carefully fumbled and felt my way across the creek, managing somehow to find a path that didn't overflow the top of my waders. I had almost reached the other shore and was just breathing a sigh of relief, when a sound like a shotgun blast erupted a few feet away. I instinctively fell into a crouch and water poured into my waders before I realized that it was a beaver slapping its tail. Fortunately I didn't drop the camera or flash unit.

Some mistakes and mishaps are not so humorous, and they can endanger not merely the photographer's equipment but his life. In May 1978 I was photographing a pair of Rufous-sided Towhees in a briar patch when it began to hail. Immediately the bird's instinct to protect the young overpowered its fear of my gear, and it rushed onto the nest with fanned wings. Fearing for my equipment, I quickly dismantled. By this time everything was drenched, and I fully expected a costly camera or flash unit repair. In my haste to get home and dry my gear, I unplugged both flash heads from the power pack without discharging their capacitors and started running to the car with a head in each hand. Suddenly they fired, sending the powerful discharge through my arms and chest. In the moment before unconsciousness, I recall thinking that someone had clubbed me across the back with a baseball bat. When I regained consciousness, perhaps minutes later, the hail had melted and everything was soaking wet. It later took me two hours with a hair dryer to dry the camera — a small price to pay under the circumstances.

Isidor once found himself buried in rubble along with his blind, tripod, and camera, for not heeding warnings about a forthcoming storm. He had been photographing a Northern Flicker which was nesting ten feet up in a dead snag,

and for this purpose he had built, on a pair of wooden horses, a platform which held his camera, lights, tripod and a blind. He had taken the precaution of roping both the platform and the blind to the ground with stakes, and the entire project seemed like a sound bit of engineering. Isidor was so deeply involved in his work that he failed to see the dark clouds gathering in the late afternoon. It was only after a clap of thunder sounded directly overhead and large raindrops began pounding on the blind that he realized his predicament. It was too late to remove the equipment, so he tried to shore up the platform in pouring rain and strong, gusty winds. Just when he felt the worst was over, a violent gust of wind ripped the guy ropes from the ground, and toppled everything on top of him. Fortunately, he wasn't seriously hurt, but his equipment was considerably damaged.

<p style="text-align:center">* * * * *</p>

When one is first learning about bird photography, there is often very little to show for the efforts involved, but the experiences are invaluable. My trip to Triangle Island, located off the northern tip of Vancouver Island, proved to be a memorable adventure in learning, although it did not achieve the hoped-for photographic results.

Triangle Island is a seabird reserve, and it has an enormous bird population comprised mainly of Cassin's Auklet, Rhinoceros Auklet, Tufted Puffin, Pelagic Cormorant, Glaucous-winged Gull, Common Murre and Pigeon Guillemot. Shortly after our arrival we climbed Puffin Rock — aptly named — where we observed several hundred Tufted Puffins, sitting only feet apart near their burrow entrances. These birds had so thoroughly honeycombed the hillsides with tunnels, that by stepping off the pathway one invariably punched through the dry earth into a burrow or tunnel. Near the summit we could barely hear each other over the cries of the Glaucous-winged Gulls circling overhead, while the fledgling gulls hid from us by tucking their heads and shoulders under the grass, leaving their posteriors in full view.

Near the edge of a cliff we found two Pelagic Cormorants' nests, and further exploration revealed the nests of the Common Murres on the ledges of the precipitous cliffs. Murres are highly sociable seabirds that live in large colonies. The parents take turns incubating their single egg and sheltering the chick after hatching. One cliff shelf, quickly estimated, contained at least 500 birds. For survival against the marauding crows and gulls, murres breed synchronously: they incubate their eggs and brood their young at the same time. When the chicks finally leave their rock shelves and plunge the 60 to 90 meters (200 to 300 feet) into the sea, the bonanza for predators is short lived, because of the vast numbers of the young birds.

The next morning, determined to photograph the cormorants basking in the early morning sun, I set up my camera on a 35 degree slope across a deep ravine from one of the nests. Just below my position, the slope made a 60 meter (200 foot) perpendicular drop to the sea. My camera was the Hasselblad EL/M with a two times extender and the zoom lens for seven power magnification. With it I was able to completely fill the frame with just the nestlings and an adult bird. Unfortunately, my tripod was not strong enough for a medium format camera

made heavier with extender and zoom lens. Another problem was the design of the extender and the zoom lens; even wide open, the light meter indicated that my exposures had to be taken at a slow 1/30 second. This meant that both camera and subject had to be absolutely motionless during the exposure. I had not bought a bracket for the flash unit, which meant carrying the power pack over my shoulder and holding the flash head in my right hand pointed at the cormorants. With my left hand I fired the prefocused camera when a lull came in the birds' activities. By the time I had taken a dozen frames, my knees were beginning to buckle and I was soaked with perspiration. When a sudden updraft funnelled up the ravine and caught me unawares, my nerves gave out and I began dismantling my equipment.

The bird I especially hoped to photograph at Triangle Island was the Rhinoceros Auklet. Studies show that the parent rhino makes only two feeding trips per day, and these occur at night. I planned to use the photo-electric triggering device on this bird. I dug a small hole just below the active rhino's burrow entrance, into which I placed the device. Its operation was simple: it fired the prefocused Hasselblad automatically whenever a pencil beam of infrared light, emitted from a flashlight clamped to a wooden stake above the burrow, was broken. When I realized that the device was malfunctioning, I decided to keep the burrow under observation and fire the camera by remote cable. Around 8:00 p.m. I took up my position concealed in a bed of tufted hairgrass. My dress consisted of two pairs of socks, hiking boots, blue jeans, rain pants, two T-shirts, a wool sweater, a vest, a coat, a nylon rain jacket, two scarves, a toque, and wool gloves — and still I felt the cold gusts coming off the Pacific Ocean. The entrance to the burrow was dimly illuminated by the flashlight, its lens covered with acetate, bathing the scene in a faint red glow. Between 10:00 p.m. and 11:30 p.m. a number of birds crash-landed in the tufted hairgrass and salmonberries. It seemed that these birds were no better able to see in the darkness than I was. Often I heard the whir of wings alarmingly close; and once I was hit squarely on the back of the head by a rhino that had taken off from a slope just above me. After landing, the adult would begin making a mewing call, which was answered by calls from the chick. When I turned on my headlamp I saw a most attractive bird with an orange-brown bill with horn — hence the name rhinoceros — and white plumes behind its eye and bill. Between 11:30 p.m. and 2:00 a.m. few birds landed, and shortly after 2:30 a.m. I came down off the slope. All I had managed to photograph was a deer mouse.

As it happened, that was my last chance for a rhino photograph. The weather took a turn for the worse and it stormed for two days, making photography difficult. The last day was perfect, and I took several scenic photographs before the helicopter picked us up.

Isidor's frustrations while photographing Atlantic coast seabirds on the other side of the continent in 1969 paralleled my own. He had obtained permission from the Environmental Protection Service in Ottawa to spend the last half of July on the tiny St. Mary's Islands, located in the Gulf of St. Lawrence. Leaving Toronto at 5:00 a.m. on the first leg of his journey, he drove almost non-stop to Tadoussac, Quebec, arriving just in time to catch the last ferry of the day across the Saguenay River. He spent the night in Escoumins, and early the next day drove to Sept-Iles,

the end of the road, some 1,600 kilometers (1,000 miles) from Toronto. There he learned that the flight to Harrington Harbour had been cancelled due to weather conditions. Finally, the next morning he boarded an old twin-engined plane bound for Havre St. Pierre, from where he took a small float plane to Harrington Harbour. From there it was a three hour trip in a small fishing boat to his final destination.

When Isidor finally had a chance to explore the island, he was rewarded with sightings of Black Guillemots, Atlantic Puffins, Razorbill Auks, Great Black-backed Gulls, Herring Gulls, Common Terns, Common Eider, and Red-throated Loons. Two young Red-throated Loons were swimming and diving in a small pond, but it would be another month before they flew. The red-throat is the smallest of the loon family of four species, all of which breed in Canada, and it is the only loon that can fly from land. Isidor decided to photograph these red-throats. When he arrived at the pond to set up the next morning, well before sunrise, the skies were clear and there wasn't a breeze — unusual on these islands which are almost perpetually shrouded in fog or swept by brisk winds. The young red-throats were enlivening the scene by frolicking in the water, rippling an otherwise mirror-smooth surface. As soon as Isidor began to set up, he became aware of a problem. The thick green carpet of moss which blanketed the island covered only rock, and he was able neither to secure the posts of his blind, nor to anchor guy wires. He finally managed to set up and left the camera and blind by the pond for an hour, to allow the loons to become accustomed to it. An hour later a stiff breeze was in the air, and Isidor rushed back to the pond, but when he arrived all that was visible was a tripod leg sticking out of the water. The camera body and lens were waterlogged but not seriously damaged, and Isidor spent the next thirteen hours sitting beside the stove for heat, while cleaning and drying the equipment. Without a camera, Isidor's purpose on the island was defeated, and he faced the same gruelling journey home, without a single photograph to show for his troubles — an expensive learning experience in terms of both time and money.

* * * * *

Not all bird photography is difficult and by far the easiest bird I have ever recorded on film is the Rufous Hummingbird. Each year a dozen or so of these tiny jewels buzz the feeder which hangs in front of the Pavlov home. Initially I placed a potted columbine plant beside the feeder, expecting at least one of the birds to be attracted to it, but as long as the feeder dispensed sugar water there were no visits to the columbine. As a last resort, I put a clear plastic bag over the entire feeder and squirted sugar water up into the carpel of the flower. Within minutes the "hummers" realized that it was no longer possible to drink from the feeder but that the columbine produced something just as tasty, creating a perfect setting for photographing these brightly colored birds.

To prevent the background from falling off into a black void, I used a laminated print, which I had taken, of out-of-focus trees and sky as a backdrop. The distance between the feeding hummingbird and this backdrop was great enough that any shadows from the flower or the bird did not fall on it, and the three strobes were positioned to prevent any undesirable reflections. I have found these pho-

tographic backdrop prints to be more realistic than sky-blue poster board. The lamination makes it waterproof.

Isidor also uses a feeder to attract birds for photography, and every winter he sets up in the same place, about 60 kilometers (40 miles) from Toronto. Here he has a chance to observe and photograph many birds not seen in the summer months. There are a number of species which breed in the far north and do not migrate very far south, for example, the American Tree Sparrow. It breeds all across Canada, just below the tundra line, feeding on insects and seeds. Banding records indicate that it can live up to nine years. After migrating in large groups, the tree sparrows break up into smaller groups of five to seven birds which stay together, arriving at and leaving the feeder in a group. Other species that gather at the feeder are Dark-eyed Juncos, Blue Jays, Black-capped Chickadees, and occasionally the Northern Cardinal. Although it is much larger than sparrows and chickadees, the cardinal poses no threat to these smaller birds, but the jay is a different matter; when it appears on the scene, all the smaller birds are driven into hiding. The Black-capped Chickadee is one of the more common visitors to the feeder. Its approach is signalled by the whir of its fast moving wings. This bird is distinguished by its habit of storing food. It likes peanuts, but prefers sunflower seeds, and after one or two feeding trips, it often returns to the feeder repeatedly, to take the food and hide it in crevices or under the bark of trees. Most birds, when they have become accustomed to the feeder and the blind, become excellent subjects for photography.

Isidor had a completely different and most memorable experience with winter photography in December of 1974. When his plant was temporarily shut down and he had a month off in the winter, he took the opportunity to go to Florida and visit Everglades National Park. Here he photographed some species of birds that he had never seen in the wild before.

The Anhinga Trail, where one can enjoy the wildlife from an elevated board-walk, begins shortly after entering the park. Not only Anhinga, but a number of other birds, the most colorful being the Purple Gallinule, take advantage of the protection of this wild park. The Anhinga is a large bird with a four foot wingspan, having a long, slender neck and a small head with a long, sharply pointed bill, It is a water bird, able to swim underwater and spear fish with its specially-adapted bill, but it also dives from the air to spear its prey in the water. After it surfaces, the Anhinga swings its bill, bringing the fish to the tip; then the fish is flung in the air and falls back into the gaping bill head first. Despite the fact that the Anhinga is a water bird, it does not have a waterproof plumage, and when it leaves the water it finds a perch in the sun to spread its wings to dry. This picturesque sight makes it very popular with visitors.

Flamingo lies at the end of 38 kilometers (25 miles) of paved road through the Everglades, but it is not a typical town. It contains no residential area, no industry, and no major business, but exists as a base for further exploration of the park. For a bird photographer there is not much of interest here except for the Brown Pelicans which perch atop pilings at the marina, providing an easy target for camera enthusiasts. Isidor's attention was caught by a large flock of small birds. They were Red-winged Blackbirds, common in the north where they breed. Here

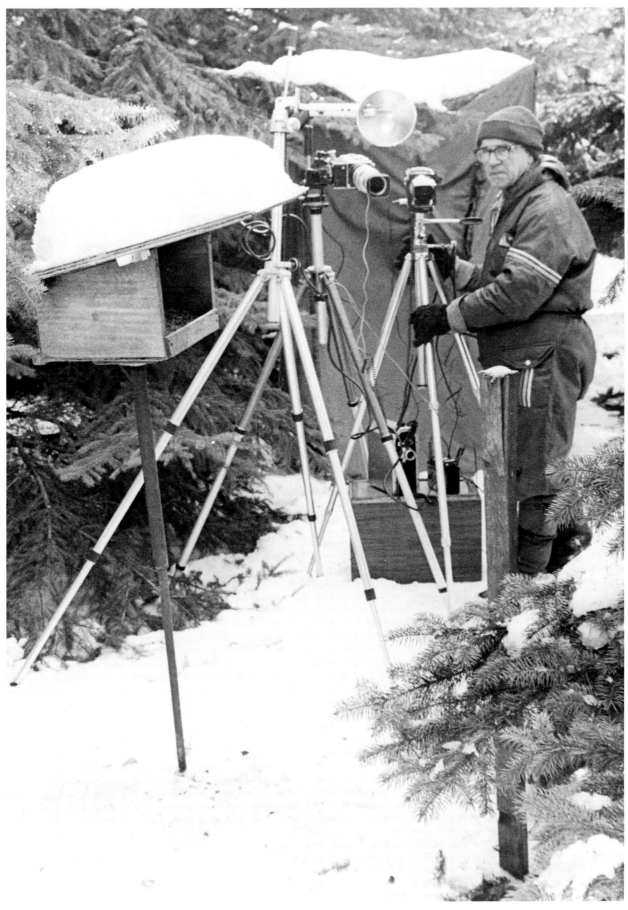

Isidor Jeklin and his setup for winter photography.

in their wintering grounds their behavior was quite different. On their breeding grounds, they normally are seen only in small numbers, whereas Isidor now saw a flock numbering up to 1,000 birds, the red on their wings flashing in the sun as they undulated in unison through the blue sky. Flamingo was a base from which Isidor drove every day to his chosen location, where he photographed a variety of birds, including the Great Egret, Snowy Egret, Tricolored Egret, Great Blue Heron, Wood Stork, Green-backed Heron, White Ibis, and the Roseate Spoonbill.

The Everglades is a unique park where the wilderness is still preserved in its natural state and where wildlife can live freely in a habitat of their own choice. The birds, a few of them on the list of endangered species, find an ideal feeding ground in this protected area. Because of this natural, but still accessible, aspect of the park, it also makes an ideal environment for the wildlife photographer and bird watcher.

<div align="center">*　　　*　　　*　　　*　　　*</div>

Although the opportunity to photograph exotic species of birds is exciting, areas closer to home can yield surprises. An alert photographer can find rare photographic opportunities practically in his own backyard. On one of his daily walks in the University of British Columbia's Research Forest, Stan flushed a small olive-colored ground-nesting bird from amongst the salal. Not wanting to chance stepping on the nest, he moved some distance away to await the bird's return. In two hours his patience was rewarded when he parted the salal bushes and discovered a tiny cup of a nest made entirely of fine grasses, and containing four cream colored eggs wreathed with small brown speckles at the larger end. After studying the parent birds with field glasses, he concluded that the pair were Orange-crowned Warblers, although he was unable to see a crown on either bird. Since these birds are thought by Dr. Eliot Porter to have some of the most difficult to locate nests of all the wood warblers, I wanted to be sure to photograph them. Six days after the eggs hatched, Stan and I began doing 4 hour shifts for 12 to 14 hours each day. We did manage to get some good shots, but although the young had beautiful yellow breasts and were most responsive, neither of the adult birds was in prime condition. However, within a few days, I discovered the unmistakable nest of another pair of orange-crowns, this one containing four eggs nestled in sphagnum moss. Since these adults were in prime condition, we decided to photograph this nest as well.

It was during this session that Stan made one of those chance recordings on film, that makes the cramped hours spent in a blind seem worthwhile to a wildlife photographer. During the absence of the adult orange-crowns a larger bird landed at the nest and began pecking at the young. Although Stan did not identify the intruder, he reacted instinctively, firing the camera and frightening off the bird. When the bird first appeared at the nest the young began a begging call, indicating that they wanted to be fed, but when they were attacked, they began a shrieking which brought the male to the nest uttering distress calls. The notes from the parent bird must have told the young to get out of the nest, as all four, although they were just beginning to feather out, immediately exploded out of the nest and fluttered into the surrounding thickets. Stan, concerned for their welfare

and knowing the danger was past, collected them all and placed them back in the nest several times, only to have them jump out again. Finally he gave up his attempts. Fortunately for the young birds, the days following their departure were sunny and warm, and two days later, the parents could be seen carrying food, a sure sign that at least one young bird had survived. The real surprise came when the film was developed. The predator, which Stan had thought to be a wren, was a Brown-headed Cowbird. Because this bird is parasitic, and lays its eggs in other birds' nests, the chance of photographing it is extremely rare, and as far as I have been able to ascertain, Stan's photograph of the cowbird's attempt to destroy another bird's young is the first such documentation on film.

<p style="text-align:center">* * * * *</p>

It was not until 1982 that I finally got my chance to photograph the dipper. I found the nest in the early part of May just above the falls on Blaney Creek and deduced that it should be ready for photography around the beginning of June. For several evenings I observed this pair feeding, marvelling at their musical communications. A few days after the young hatched, Stan and I began to set up. We discovered that early morning was the best time to photograph these birds. Shortly after 6:00 a.m., the female flew out of the nest. In the first hour she made four trips back with two-inch-long salmon fry. Her movements soon became totally predictable. Landing at the water's edge just below the nest, she carved the fry in half by rubbing it against a rock. She then landed on a rock outcropping adjacent to the nest, and after a moment's hesitation fed the two halves to the first two young to poke their heads out of the nest. She soon became so accustomed to our presence that when I placed my hand in front of her nest, she would serve the food to her young between my fingers. Around 7:00 a.m. the male made an appearance. He was much chunkier than his mate, not surprising since he averaged one trip to the female's four, and usually brought stonefly or mayfly nymph instead of the faster swimming fry. Around 8:00 a.m. the feeding switched to only nymph, and by 10:00 a.m., when it became quite warm, the feeding trips dwindled to one every two hours.

Two bird species which live in close proximity in the marsh, although not in harmony, are the Marsh Wren and the Red-winged Blackbird. The tiny wren can be vicious, and when nesting in a common territory, will break the eggs or attack the nestlings of neighbouring birds. Both blackbirds and wrens are polygamous when conditions are favorable, so that the female feeds and tends the young, as the male is usually preoccupied with chasing off rival males. If the food supply is scarce, and the female Red-winged Blackbird must venture far from the nest, the wren will take the opportunity to destroy the blackbird's offspring. My experience with Marsh Wrens and Red-winged Blackbirds indicates that blackbirds like to nest in the middle of the deeper portions of the marsh while wrens prefer hardhack thickets on or near shore.

The relationship between Marsh Wrens and other bird species was graphically demonstrated in 1977 when I was photographing an Eastern Kingbird nest. This nest, which contained two young, three to four days old, was built well out on the limb of a red alder and over water, making set up difficult. Then I discovered

that the kingbird parents were reluctant to accept my photographic equipment. Leaving some of the gear set up, I moved the rest of it back from the nest to give the birds time to adjust. There I fell asleep, awaking to a great commotion at the nest. When I approached, a small brown bird was frightened off the nest. Throughout all the excitement both kingbird parents hovered nearby, but their fear of my equipment overrode their instincts to defend their young, which had been killed by the wren.

<p style="text-align:center">* * * * *</p>

Some aspects of bird photography are best handled by two people, and Isidor and I have developed partnerships with other bird enthusiasts and photographers which have been richly rewarding. Stan Pavlov and I have worked together for many years and Isidor's longstanding partner is Larry Parsons. Ingenuity is one of the prerequisites of a wildlife photographer, who is often called upon to devise his own props in the field, or to construct equipment which is simply not available commercially. Here two heads are better than one, and the labor of packing in equipment, setting up scaffolding and blinds, and 12 to 14 hour photographic sessions, is easier when shared.

The ultimate challenge in bird photography involves the higher nesting birds, especially the birds of prey such as eagles, owls, and hawks, since a blind must be erected at nest level or higher, and at a suitable distance from the nest. A project of this magnitude usually is attempted only by a team of two photographers. Isidor and Larry have had some interesting experiences photographing some of these raptors, two of which were the Great Horned Owl and the Northern Goshawk. Great Horned Owls do not build nests, but simply take over the unoccupied nests of other birds, or those of squirrels. On this occasion the site chosen was the abandoned nest of a Red-tailed Hawk, situated 16 meters (fifty feet) up in a maple tree. Widespread over most of the North and South America, the breeding season for this large, majestic bird starts during the cold winter months, and it is not unusual to find fresh snow covering both nest and owl during the incubation period. Incubation takes thirty days and for this particular pair, hatching day came on April 3. The food, provided by the male, was already placed over the nest and consisted of a rabbit and two rats. Ten days later, Isidor and Larry began putting up the tower and blind.

The scaffolding, which was previously prepared and left waiting nearby, was carried out to the site and erected piece by piece. Since their presence disturbed the parent birds, they never worked longer than one hour at a time, and then only during warm afternoons so that the chicks would not become chilled during the parents' absence. It took them six days to set up, but by April 19, the eyes of the young had opened, and conditions were ideal for photography. As owls feed at night, Isidor entered the blind at dusk. The nest was faintly illuminated by a six volt bulb powered by his flash battery. When hunting was good there might be five or six feedings a night, but this often dwindled to one or two. When the young were 68 days old they left the nest. They could not yet fly, but upon jumping from the nest, they flapped their wings until they reached the ground. There the parents continued to feed them until they were strong enough to fly.

Isidor and Larry also photographed the aggressive Northern Goshawk, nesting at a relatively low 10 meters (33 feet) above the ground. The female, noticeably larger than the male, was the fiercest in defending the nesting territory, and tried to strike the heads of the intruders by diving rapidly, while uttering a loud *cac cac cac*. For protection both men wore helmets while erecting the tower. Once inside the blind they were safe and their photography did not appear to disturb the birds.

There was very little available light in this setting, and with no way in which to light the distant background with artificial light, Isidor had to compromise by using a wide aperture with a slow shutter speed. The photographs were taken at f-8 at 1/15 second, barely enough light to avoid a black background. The birds of course were illuminated with flash. With the lens opened up to f-8 the depth of field was extremely shallow, and, because he was shooting at such a slow shutter speed, both the camera and the subject had to be absolutely motionless to prevent blur.

For the first ten days the female brooded constantly and the male only came in to drop the food. It was the female's job to tear it into small bits with her powerful beak and serve it to the young. Once the young were ten days old, the female occasionally left the nest but remained nearby, patrolling the territory and keeping watch. When the male (who was the sole provider) arrived with food, the female returned to the nest for about fifteen minutes and fed it to the young. Feeding times were irregular, which is common among predators, as their elusive prey is unpredictable. A chipmunk was the usual menu for the first three weeks. Later, when the young goshawks were able to swallow larger morsels, the food was usually the plucked nestling of a small bird, which was dropped by the adult in flight, and picked up by the young and swallowed whole. Once the young reached this stage of development the female did not bother coming into the nest, ending any further chance for photography. The young goshawks left the nest when forty days old. Although the Northern Goshawk is not a common bird, it is not a rare or threatened species either, and an encounter with one is uncommon only because it frequents the deep woods far from human habitation.

The Marsh Hawk, unlike the hawks, kites and their larger cousins, the eagles, is a harrier, and in a recent change in classification, it has been officially renamed Northern Harrier. The distinguishing feature of this bird is its facial disc, resembling that of an owl. The male is a light blue-gray above, with primarily whitish underparts and blackish wing tips. The female is larger and predominantly brown. Both have yellow eyes and feet and a pure white rump patch. It is a common bird, found coast to coast from Alaska to Mexico.

Larry flushed a harrier from its nest, which contained six white eggs, lightly speckled with brown, in late spring 1978. The nest was almost non-existent, consisting of just a few weed stems around the eggs. It was well concealed in a heavy growth of tall gray goldenrod. Larry and Isidor, planning to photograph this nest, kept it under observation, and a week later the eggs hatched.

They proceeded with caution on this project, in order to test the harrier's reaction. The first day Larry left the disassembled blind on the ground in the vicinity of the nest. The following day he erected the blind to a height of one and a

half feet. The female harrier circled above and swooped down on him several times, in an attempt to drive him away. The next day the blind was raised to three feet with diminishing opposition from the bird. Assured of the bird's acceptance a day later, they raised the blind again, this time to the full height of 1.7 meters (6 feet).

Both harrier parents hunt for food, but the female was never far from the nest, and did all the feeding. The male seldom made an appearance at the nest, but could be seen in the air during food transfer between the adult birds, which was accomplished in mid-air. The male arrived with the food and circled above the nest until the female began flying below. When the male dropped the food, usually a skinned nestling, the female caught it in mid-air with her talons, then brought it down to the nest.

Isidor soon realized that the 250 mm lens he was using was fine when the birds were on the ground, but it could not catch the mother in flight, as the wings overfilled the frame. This was a good opportunity for him to use two cameras. He fitted the second with a 150 mm lens, with cross-coupled synchronization with the other camera, so that the same flash equipment could be used for both. Isidor followed the bird's movements through the viewfinder. It was a complicated procedure that worked well, resulting in full-frame dramatic shots of the adult both landing and feeding her young.

Photographing these high-strung, difficult to locate raptors is undoubtedly one of the most time consuming projects a bird photographer can undertake. But almost any nesting situation requires uncounted hours of work, and the nature photographer must be prepared to pay a high price for his achievements. He will soon discover that a particular situation has a specific time allotment, and that if the moment is missed, it is gone forever. In many instances, the opportunity for a second chance at a species never comes the photographer's way again. The photographer must be prepared to sacrifice time, comfort and social activities in order to grasp that opportunity when it presents itself.

It takes a mere fraction of a second to record a picture on film, yet this fraction represents untold hours of labour. The finished photograph ideally captures those qualities which first captivated the photographer, transmitting in a lasting form the beauty of birds in their forest environment. If this can be appreciated and understood by others, then the photographer is well rewarded.

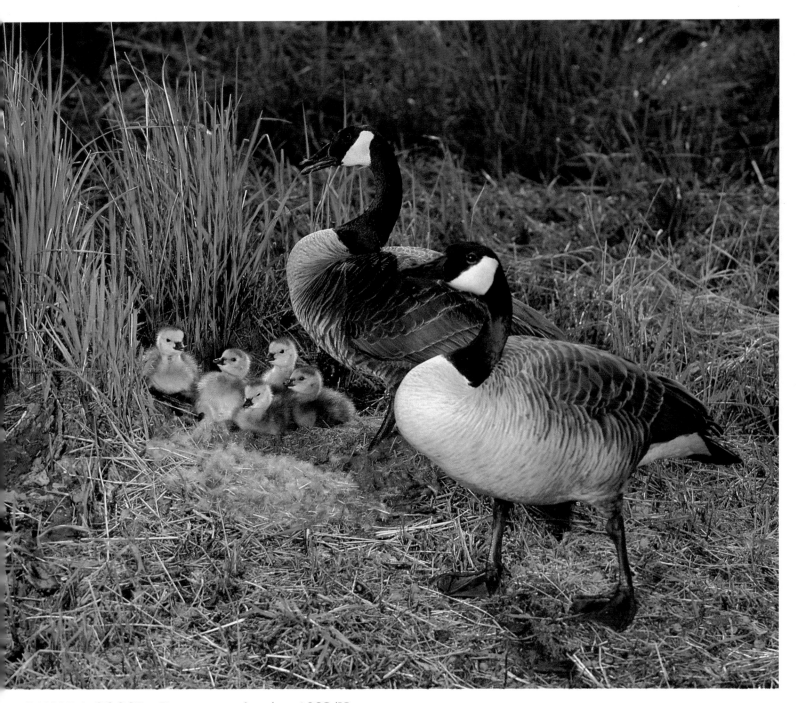

CANADA GOOSE Branta canadensis 1983/IJ

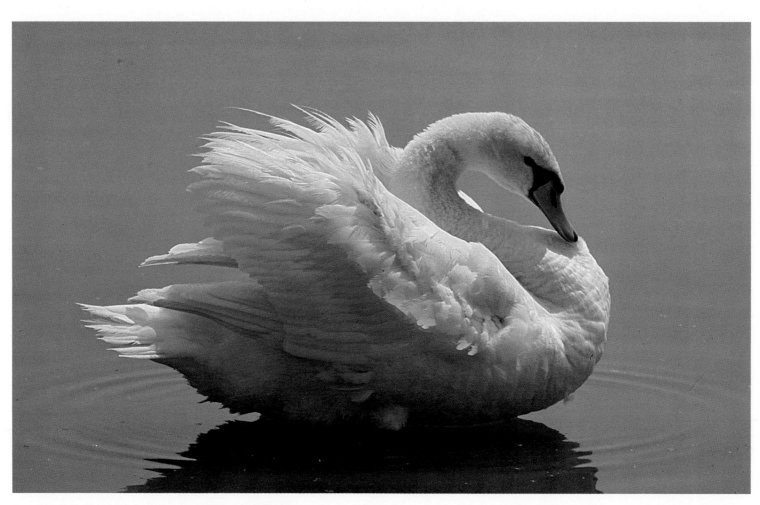

2 MUTE SWAN Cygnus olor 1972/IJ

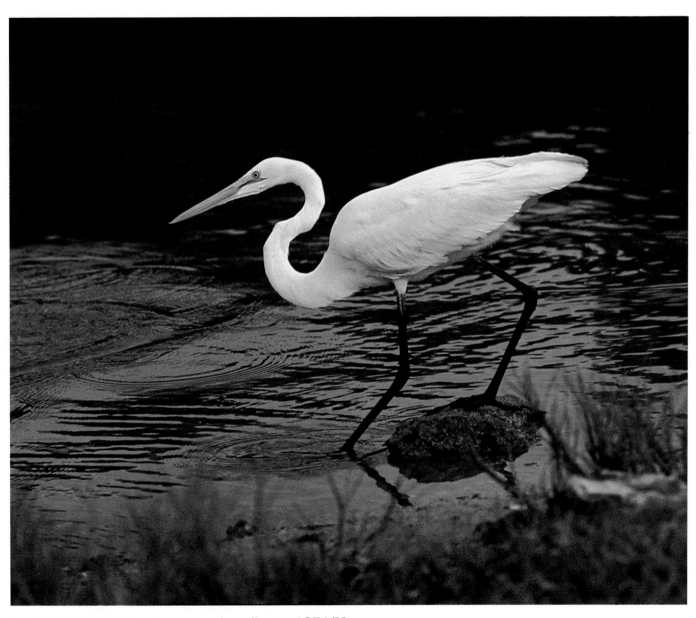

3 GREAT EGRET Casmerodius albus 1974/IJ

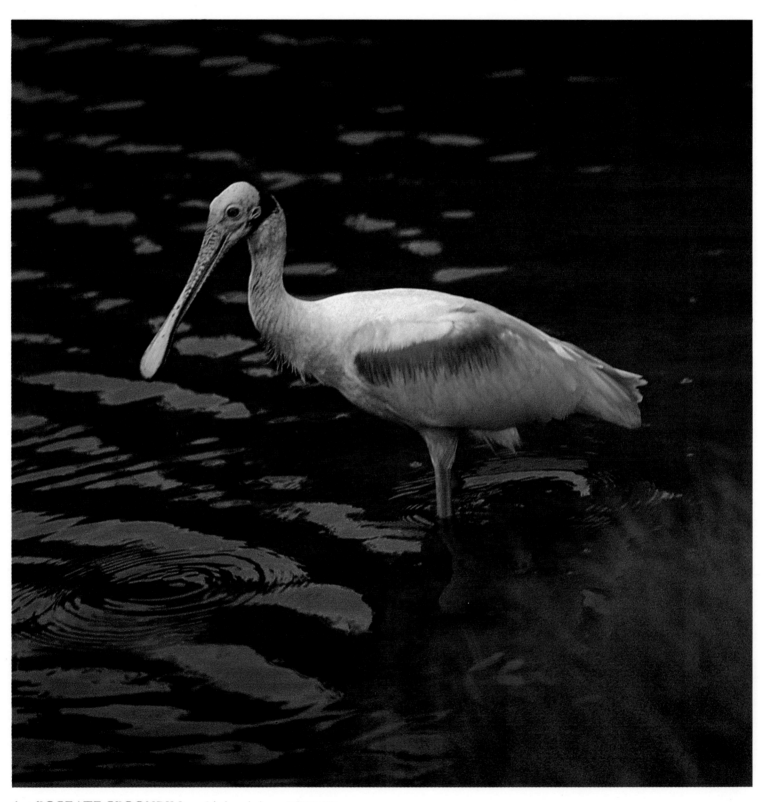

4 ROSEATE SPOONBILL Ajaia ajaja 1974/IJ

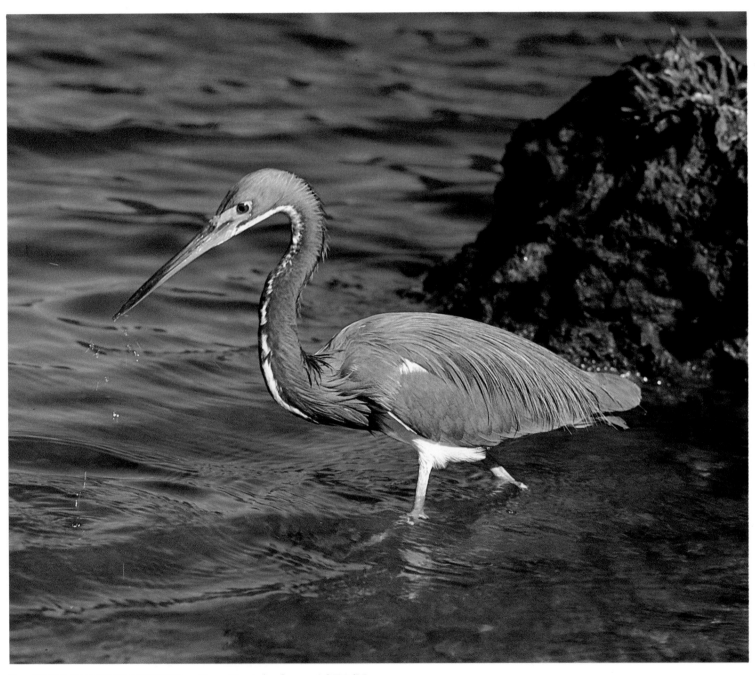

5 TRICOLORED HERON Egretta tricolor 1974/IJ

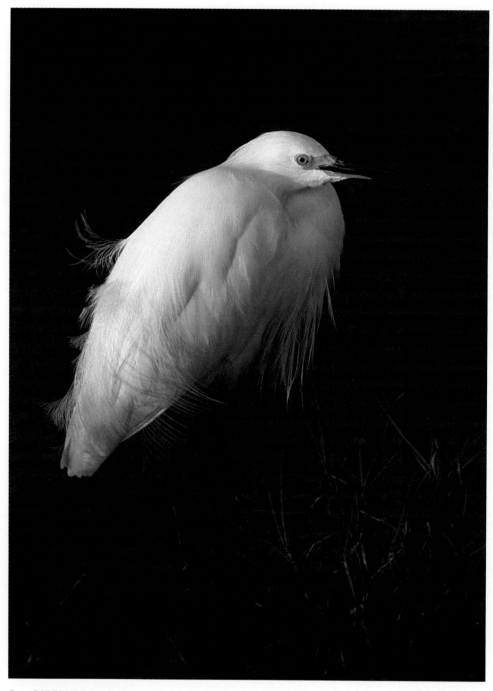

6 SNOWY EGRET Egretta thula 1974/IJ

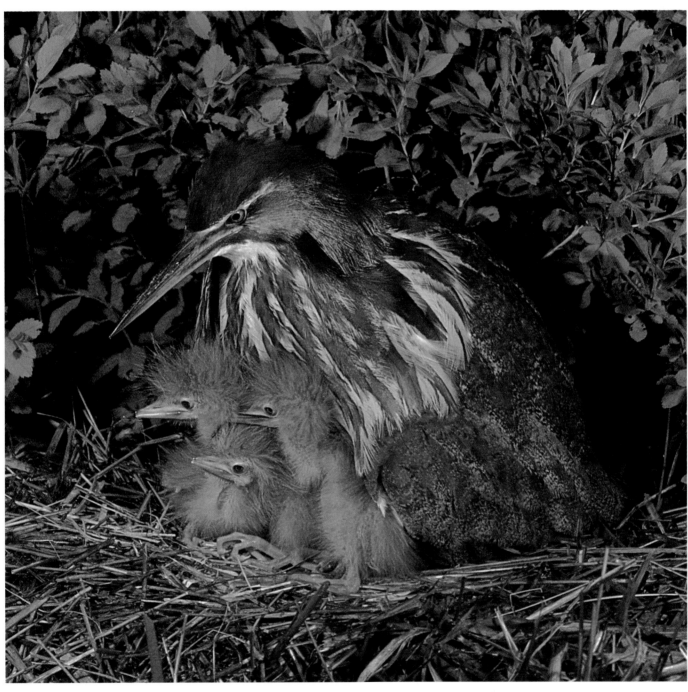

7 AMERICAN BITTERN Botaurus lentiginosus 1976/IJ

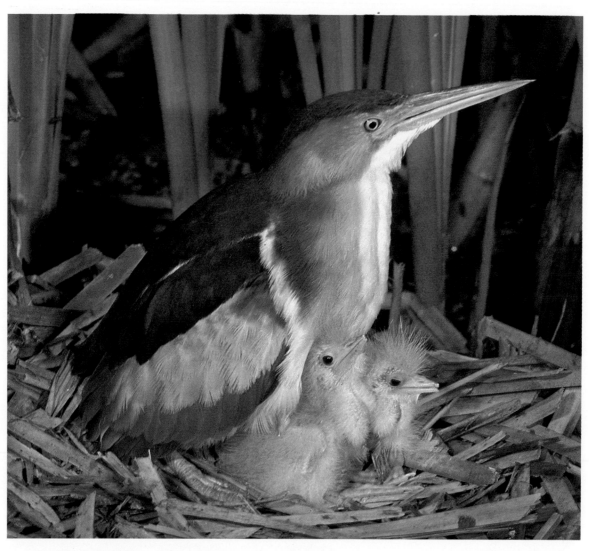

8 LEAST BITTERN Ixobrychus exilis 1972/IJ

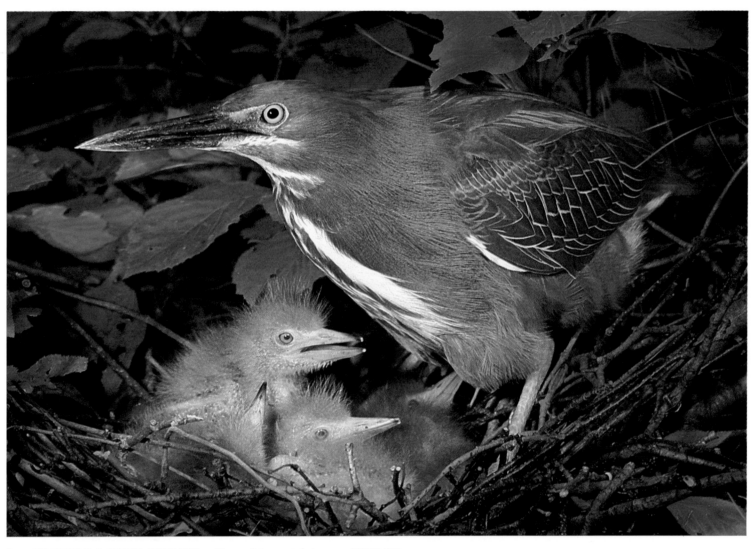

9 GREEN-BACKED HERON Butorides striatus 1972/IJ

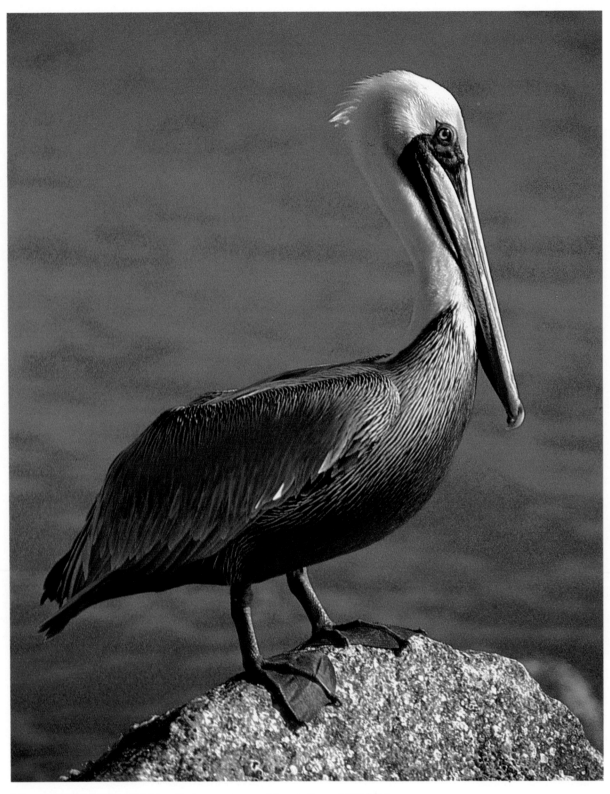

10 BROWN PELICAN Pelecanus occidentalis 1974/IJ

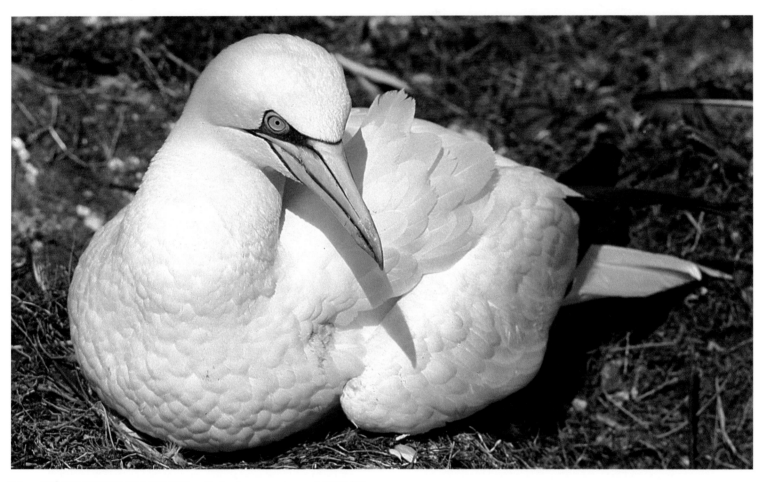

11 NORTHERN GANNET Sula bassanus 1972/IJ

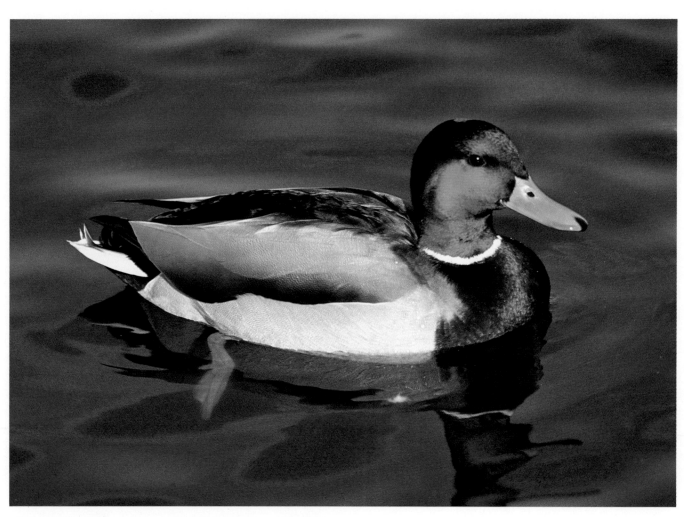

12 MALLARD Anas platyrhynchos 1972/IJ

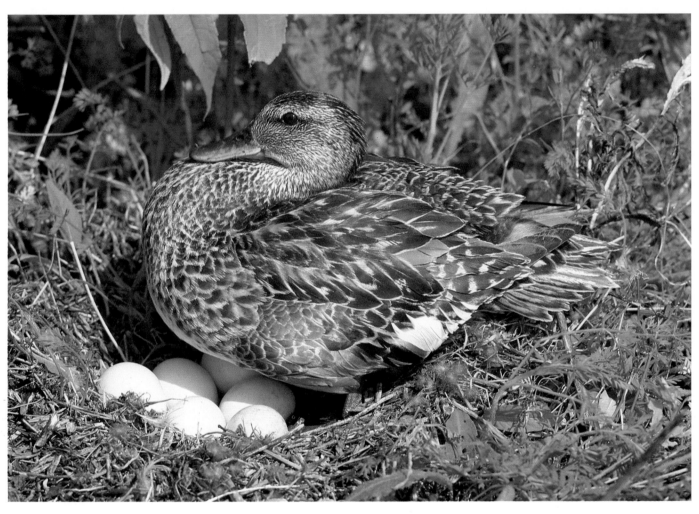

13 GADWALL Anas strepera 1982/IJ

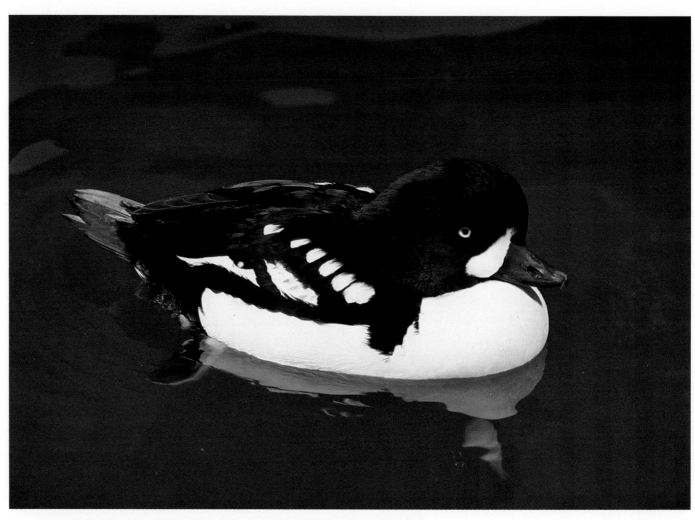

14 BARROW'S GOLDENEYE Bucephala islandica 1978/IJ

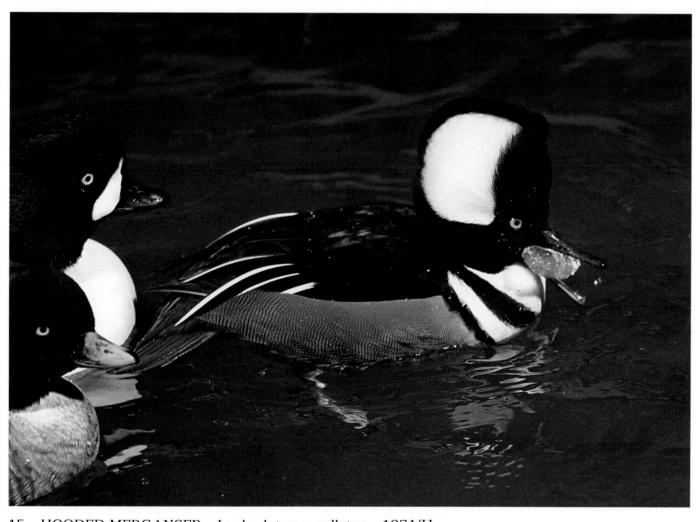

15 HOODED MERGANSER Lophodytes cucullatus 1974/IJ

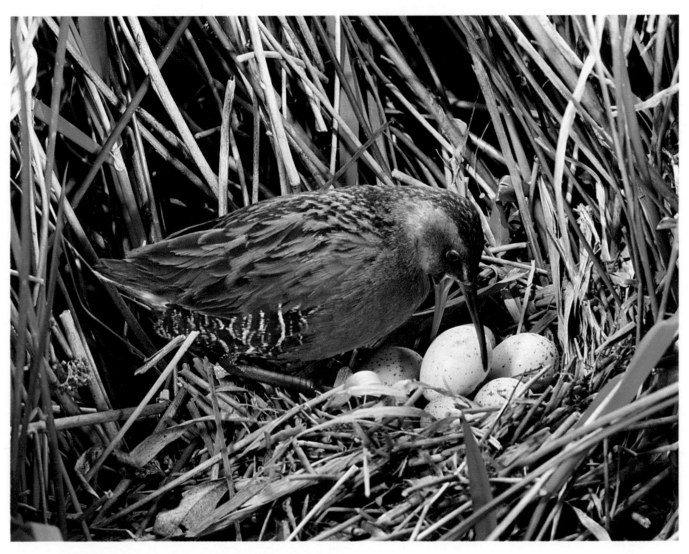

16 VIRGINIA RAIL Rallus limicola 1983/DEW

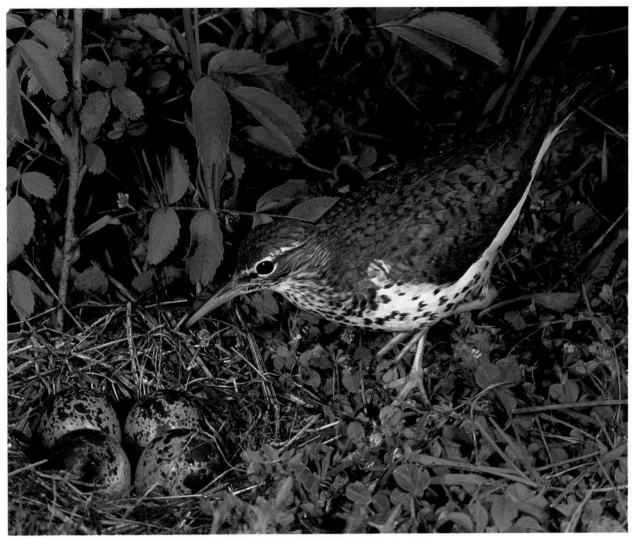

17 SPOTTED SANDPIPER Actitis macularia 1977/IJ

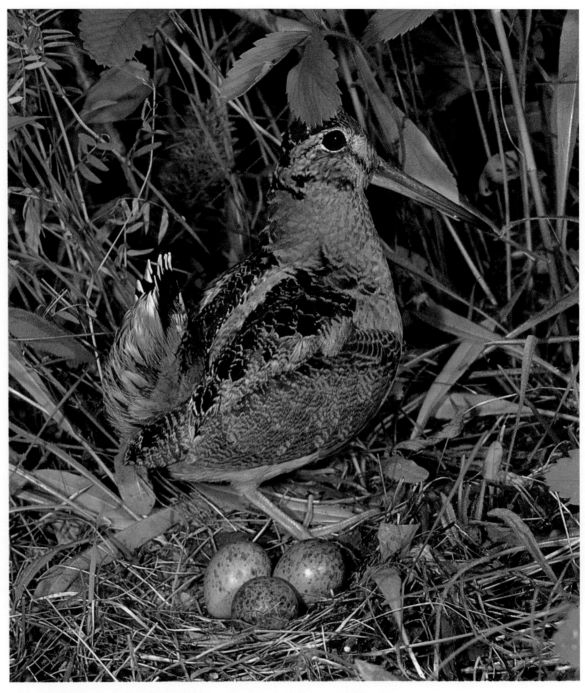

18 AMERICAN WOODCOCK Scolopax minor 1974/IJ

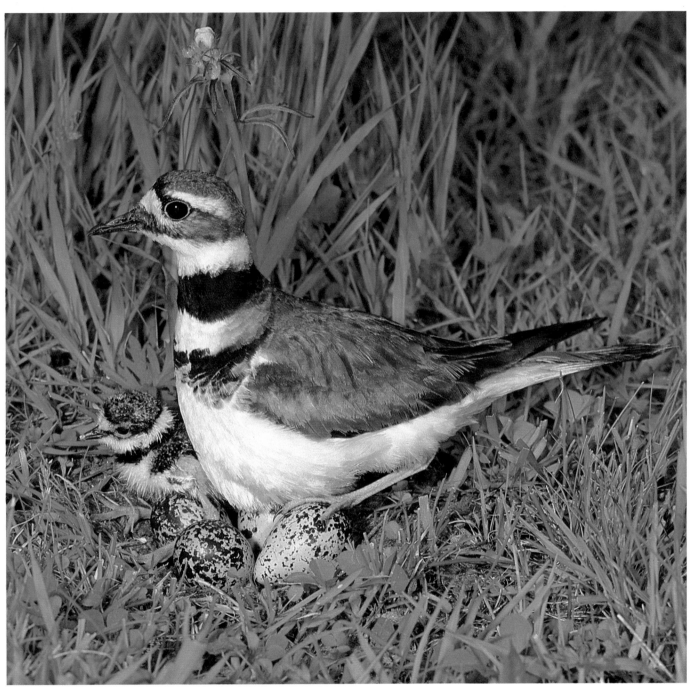

19 KILLDEER Charadrius vociferus 1976/IJ

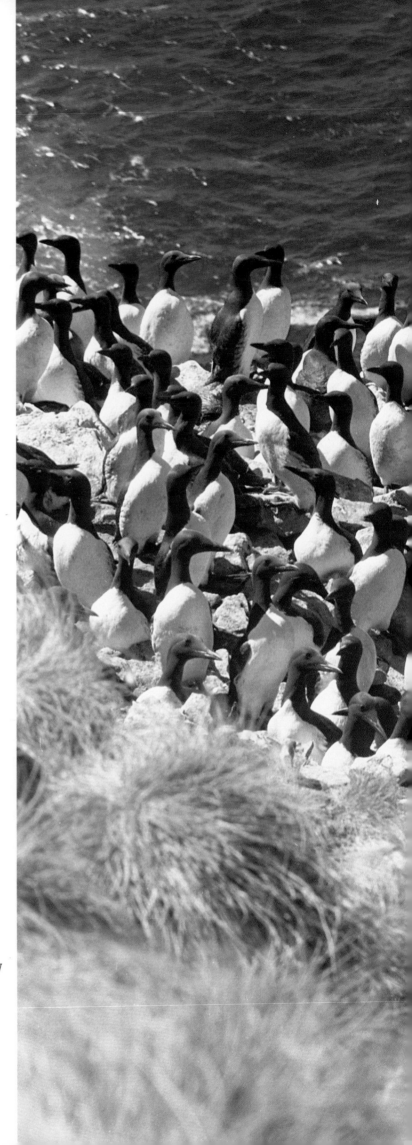

20 COMMON MURRE Uria aalge 1981/DEW
Anne Vallée Ecological Reserve,
Triangle Island, British Columbia

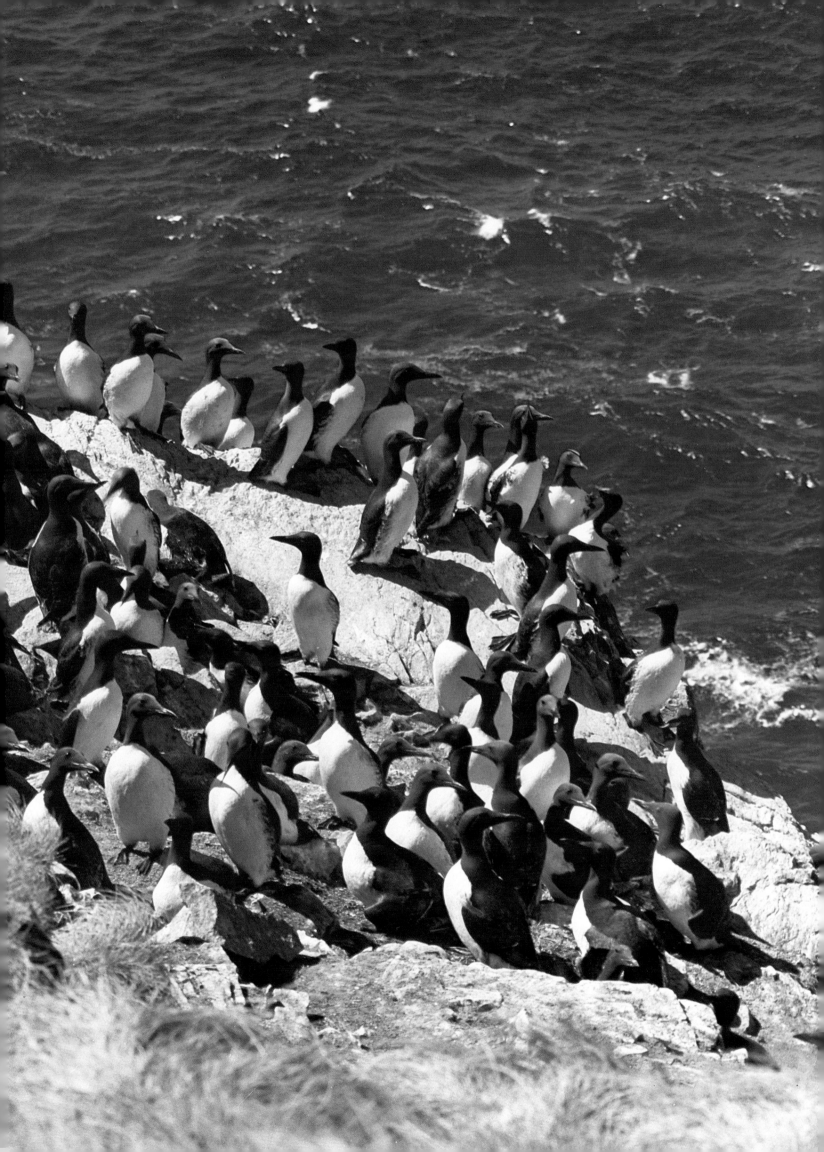

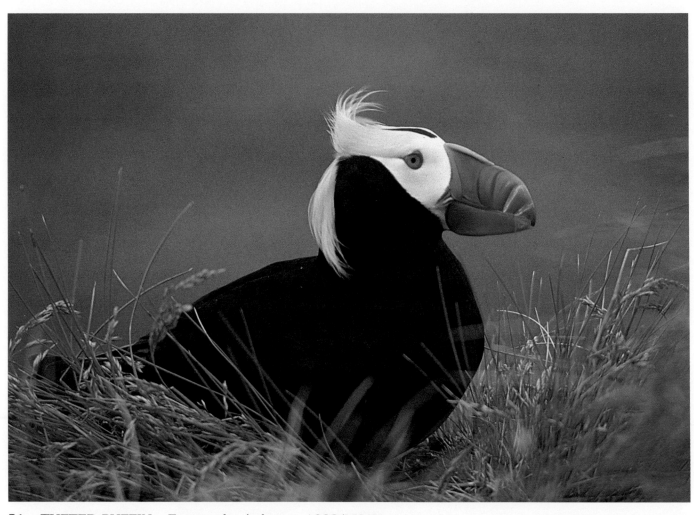

21 TUFTED PUFFIN Fratercula cirrhata 1982/MJAV

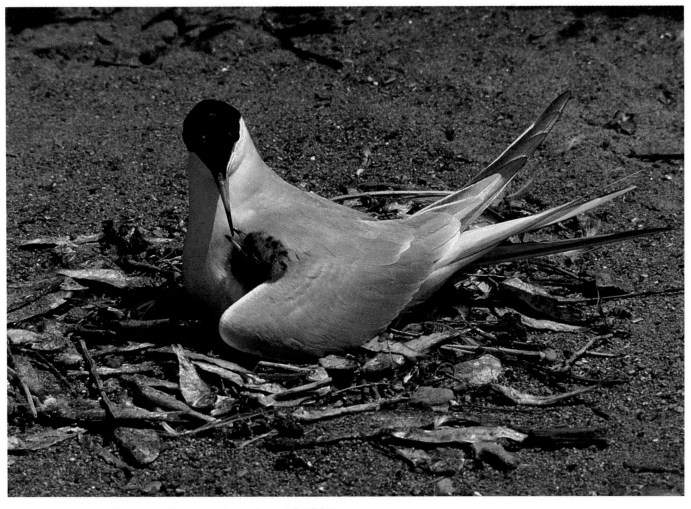

22 COMMON TERN Sterna hirundo 1976/IJ

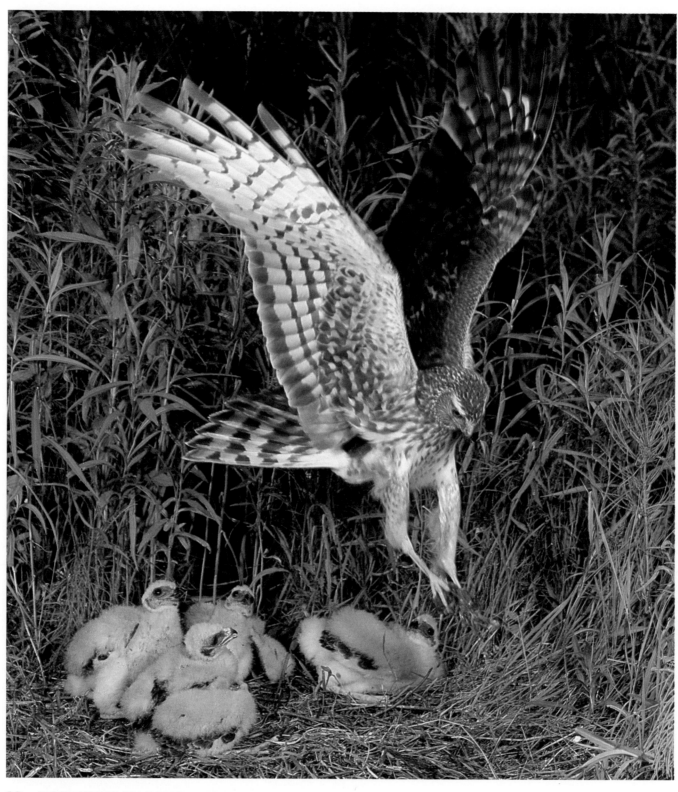

23 NORTHERN HARRIER Circus cyaneus 1978/IJ

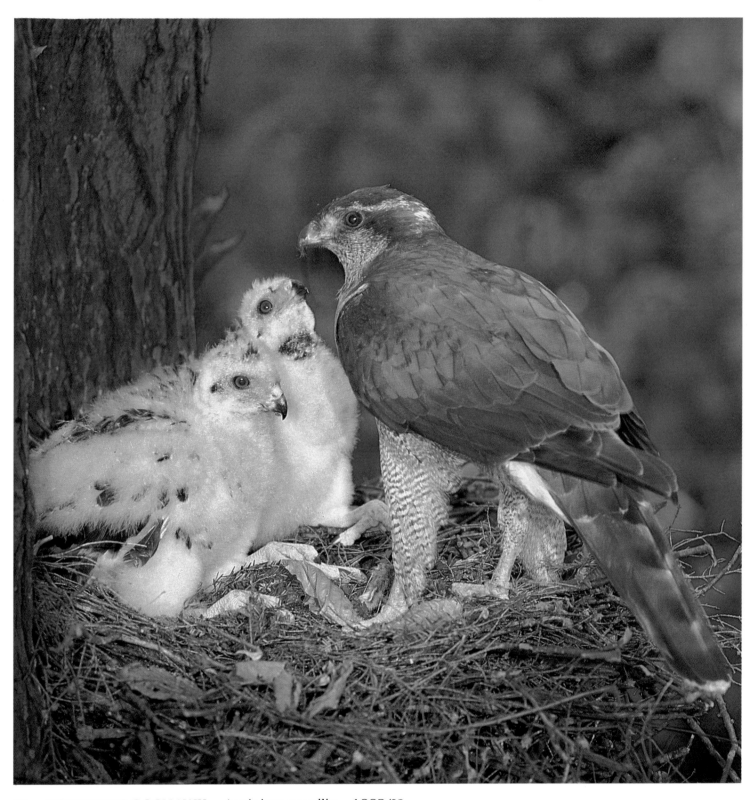

24 NORTHERN GOSHAWK Accipiter gentilis 1983/IJ

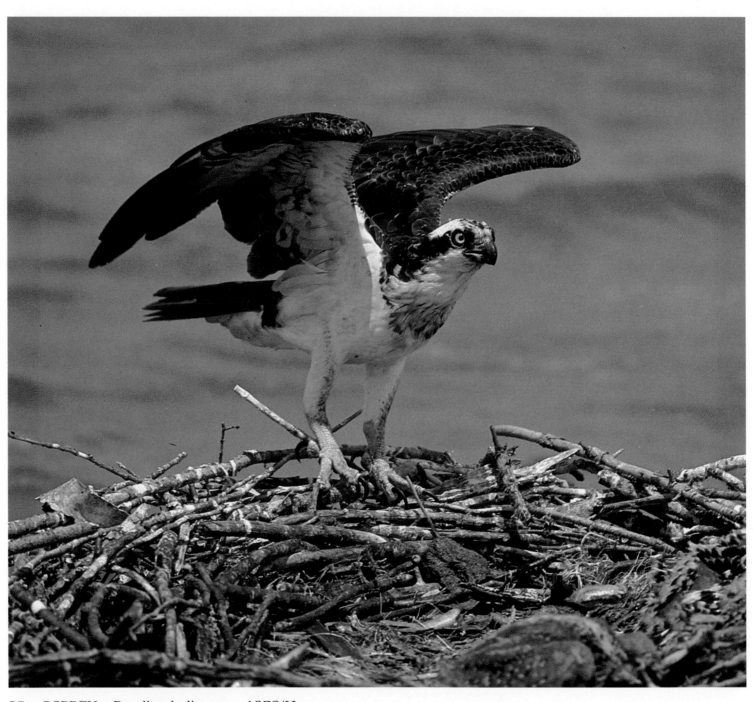

25 OSPREY Pandion haliaetus 1976/IJ

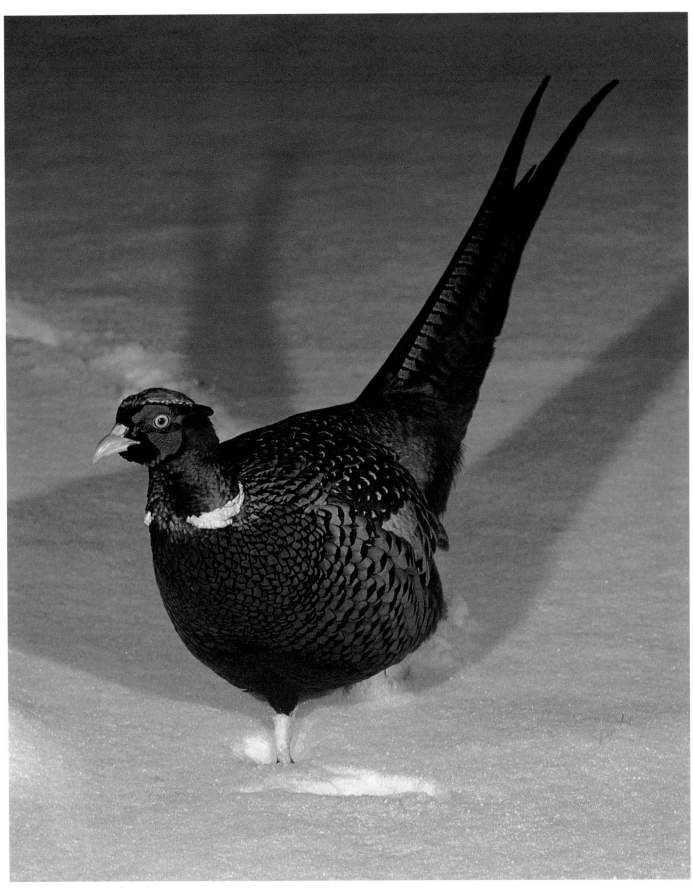

26 RING-NECKED PHEASANT Phasianus colchicus 1978/IJ

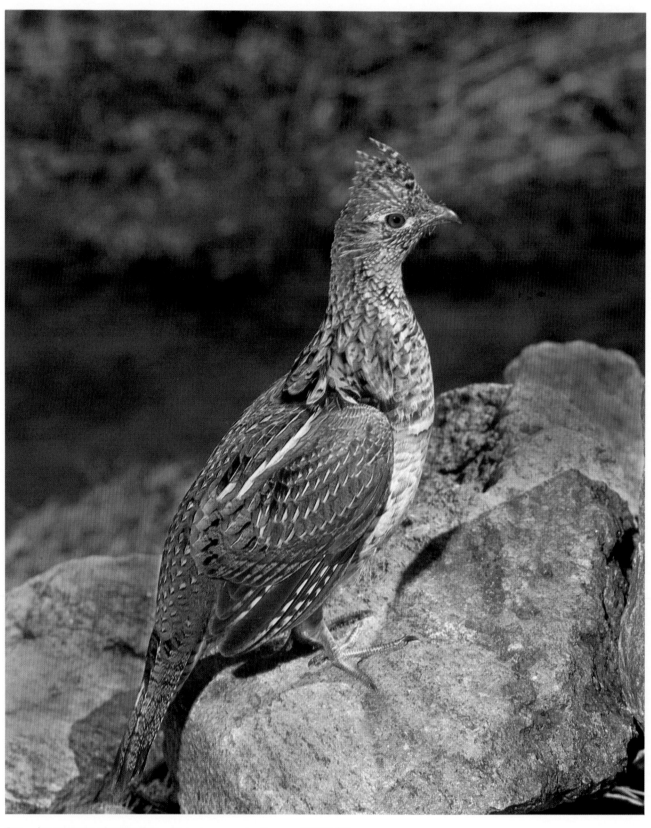

27 RUFFED GROUSE Bonasa umbellus 1982/IJ

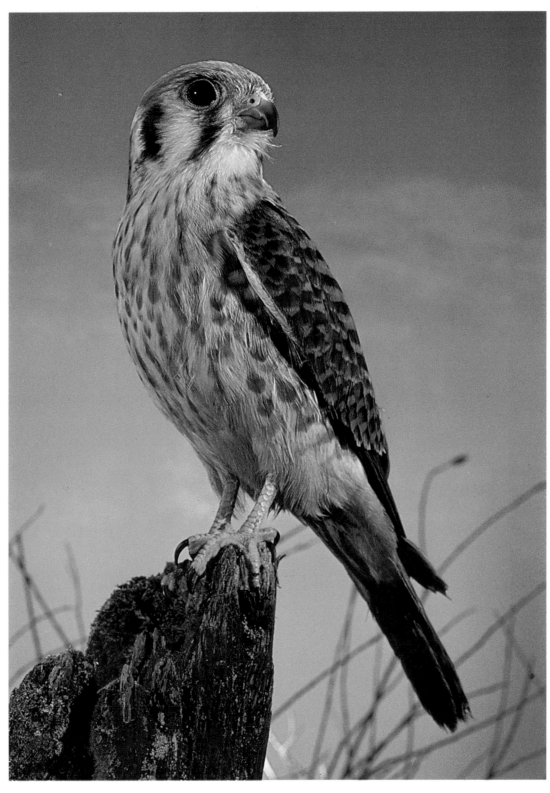

28 AMERICAN KESTREL Falco sparverius 1976/IJ

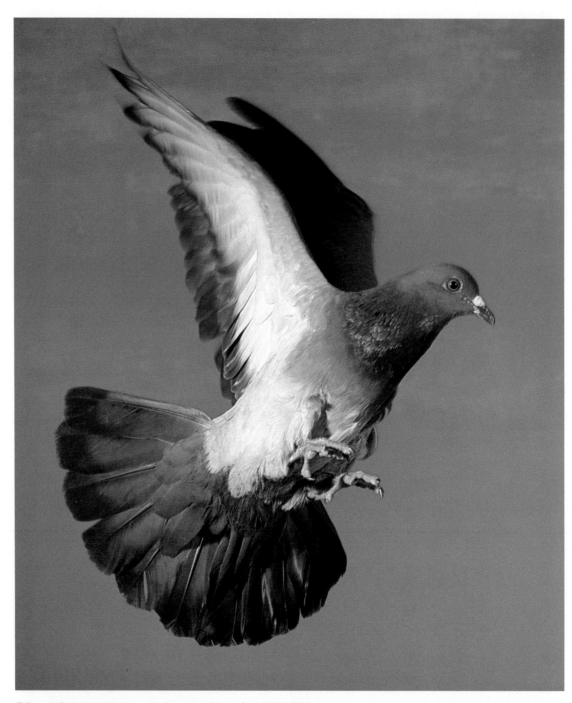

29 ROCK DOVE Columba livia 1977/IJ

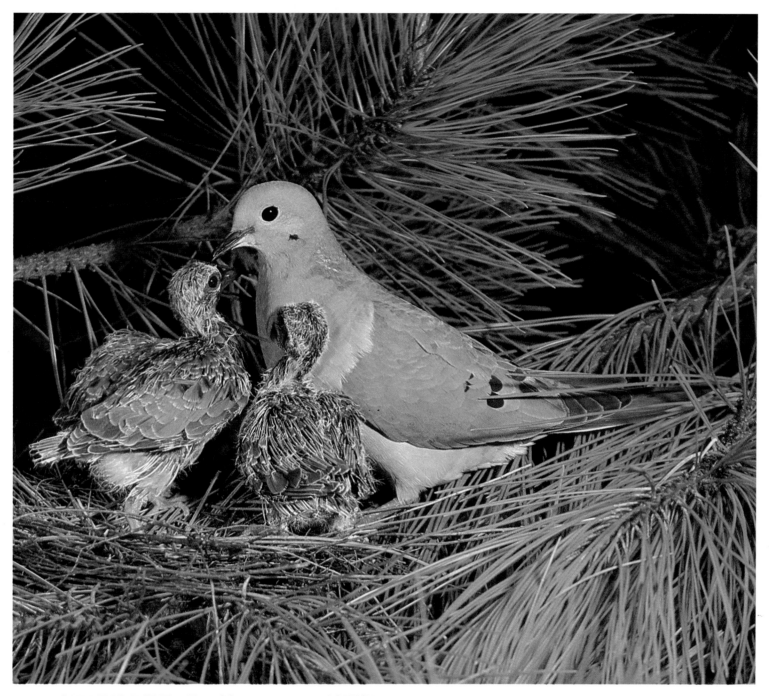

30 MOURNING DOVE Zenaida macroura 1977/IJ

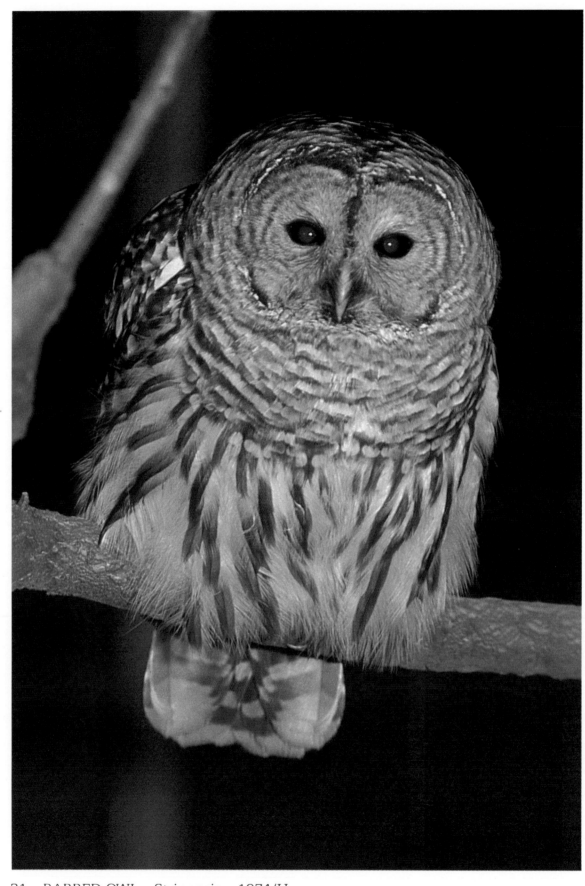

31 BARRED OWL Strix varia 1974/IJ

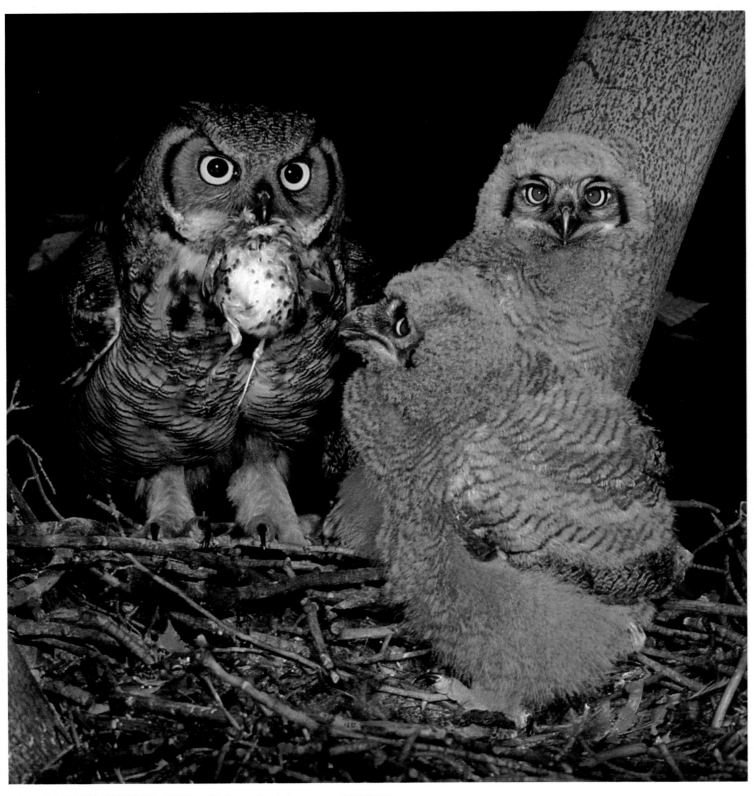

32 GREAT HORNED OWL Bubo virginianus 1980/IJ

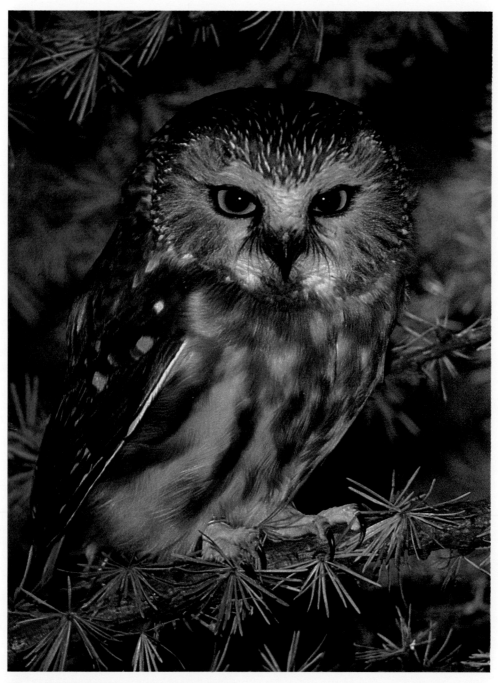

33 NORTHERN SAW-WHET OWL Aegolius acadicus 1977/IJ

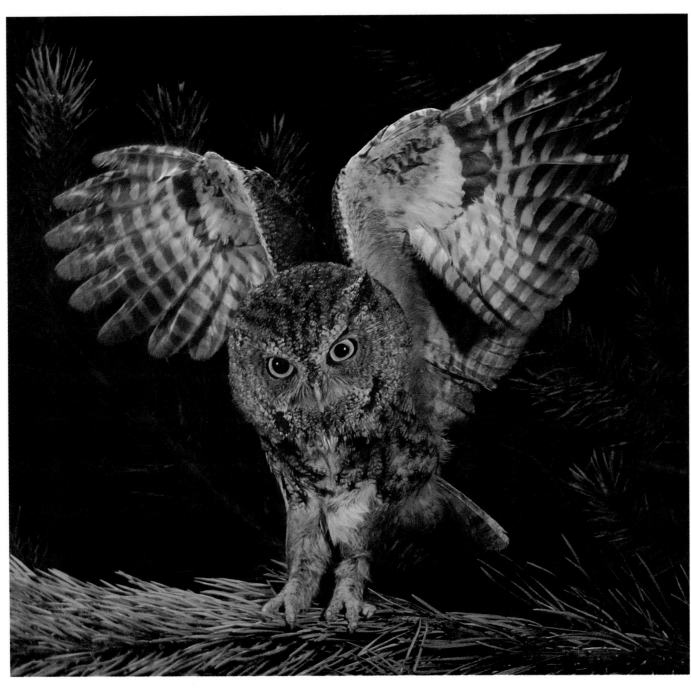

34 EASTERN SCREECH-OWL Otus asio 1977/IJ

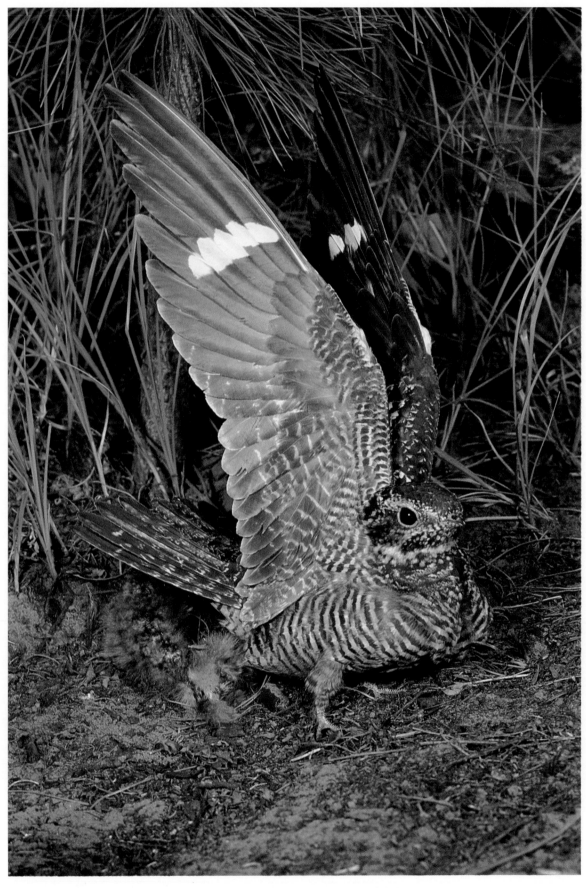

35 COMMON NIGHTHAWK Chordeiles minor 1978/IJ

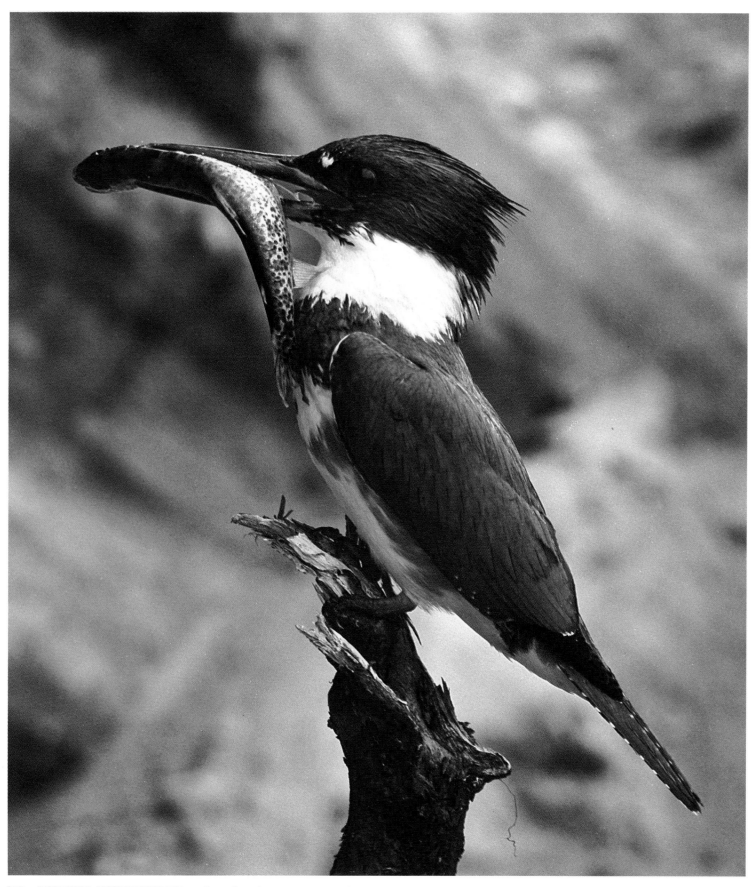

36 BELTED KINGFISHER Ceryle alcyon 1980/DEW

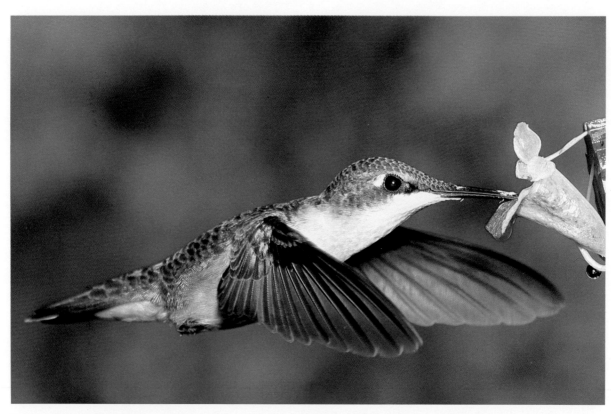

37 RUBY-THROATED HUMMINGBIRD Archilochus colubris 1981/IJ

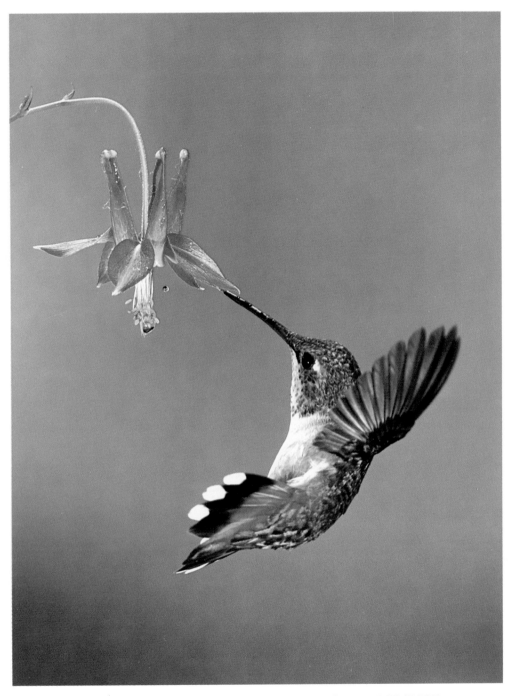

38 RUFOUS HUMMINGBIRD Selasphorus rufus 1983/DEW

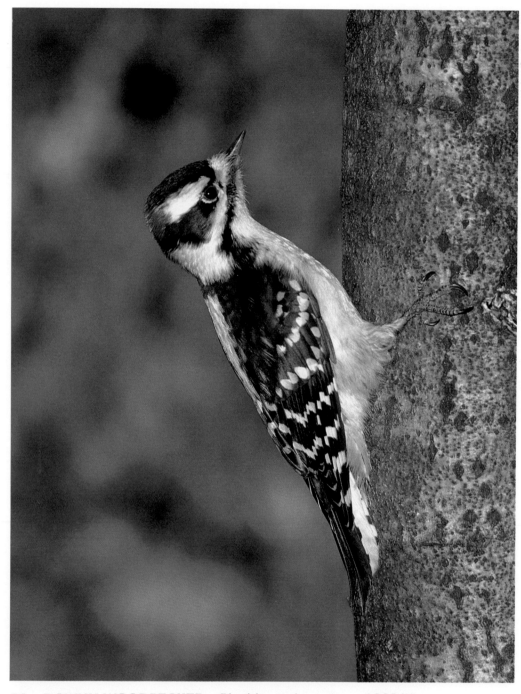

39 DOWNY WOODPECKER Picoides pubescens 1983/IJ

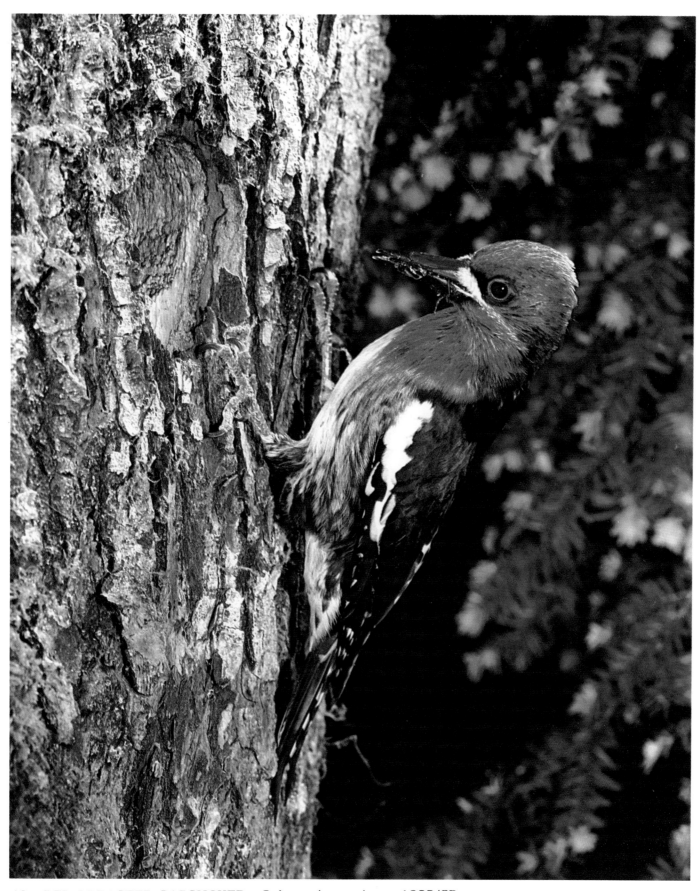

40 RED-BREASTED SAPSUCKER Sphyrapicus ruber 1982/SP

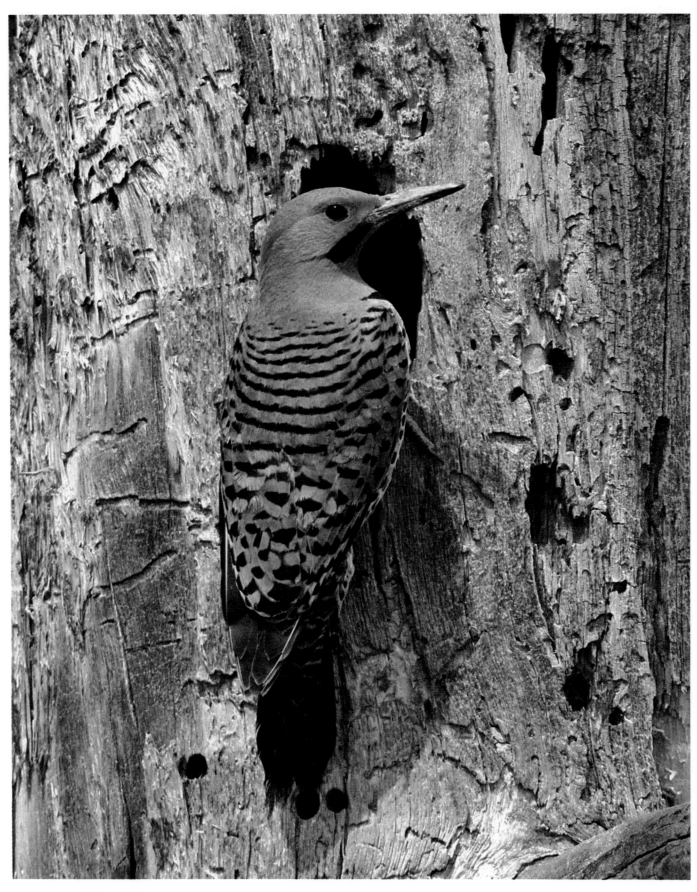

41 NORTHERN FLICKER Colaptes auratus 1978/DEW

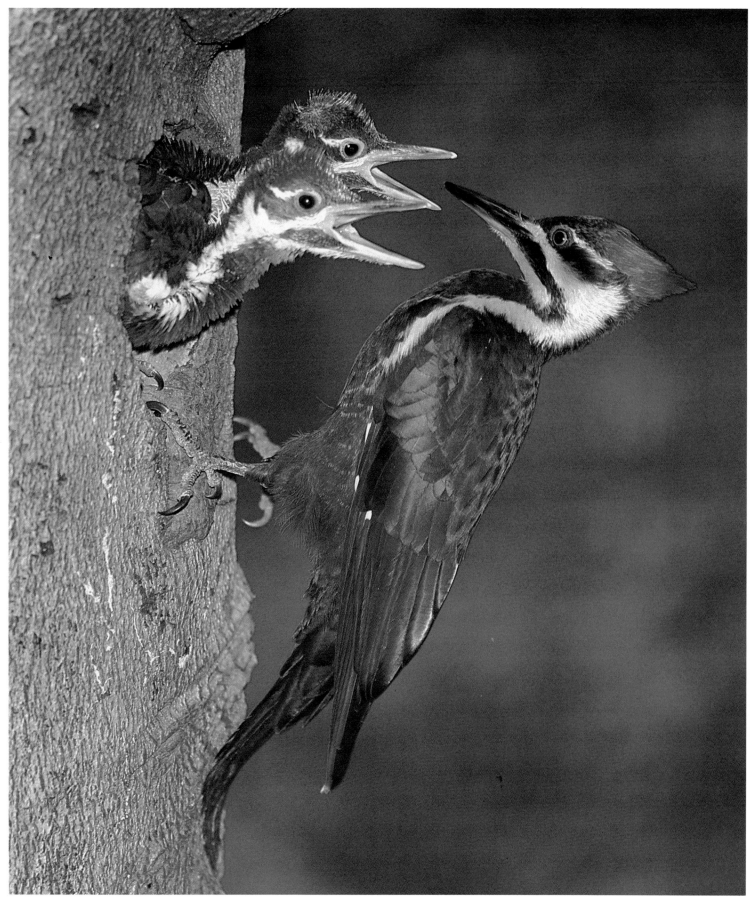

42 PILEATED WOODPECKER Dryocopus pileatus 1983/IJ

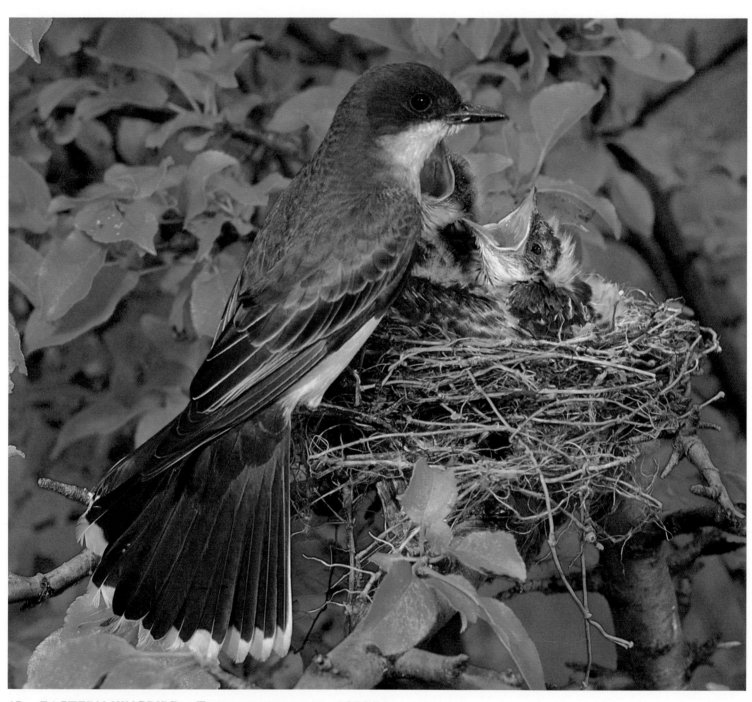

43 EASTERN KINGBIRD Tyrannus tyrannus 1978/IJ

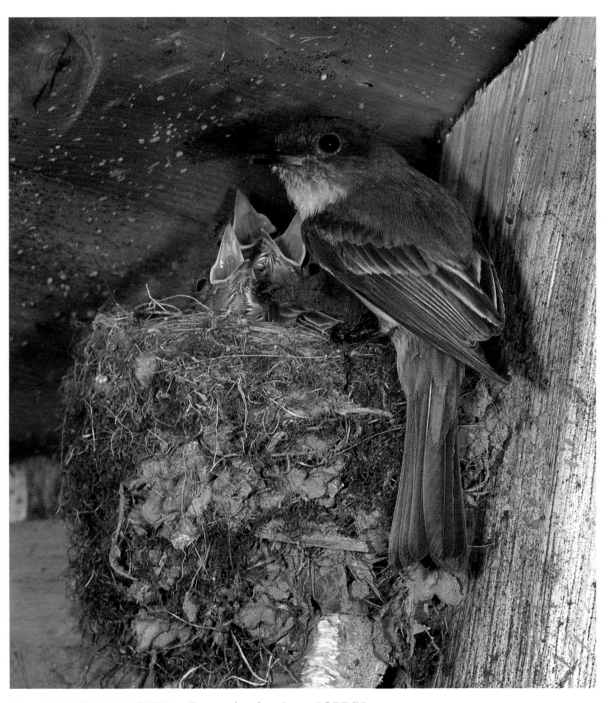

44 EASTERN PHOEBE Sayornis phoebe 1975/IJ

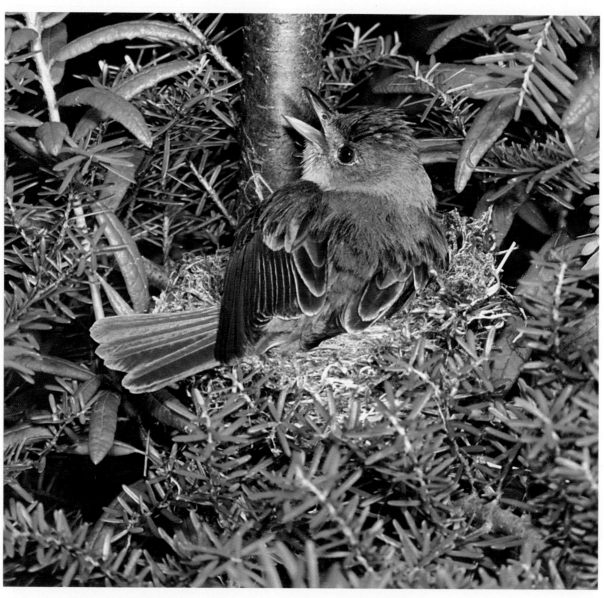

45 WILLOW FLYCATCHER Empidonax traillii 1978/DEW

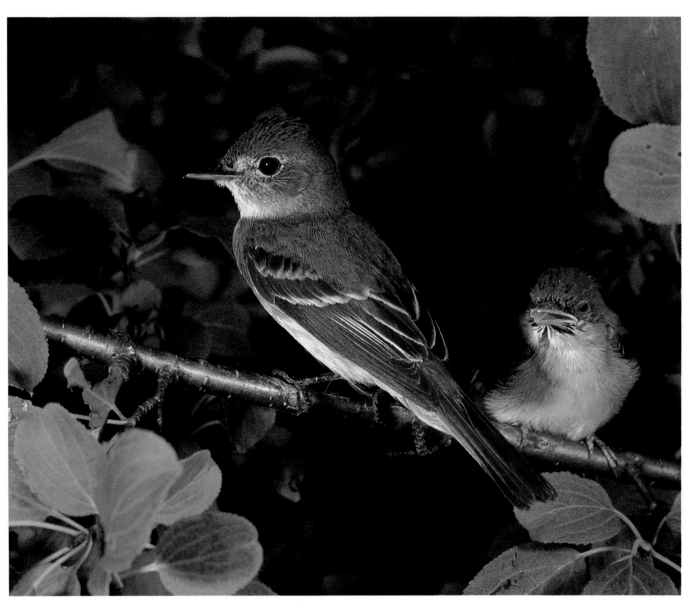

46 LEAST FLYCATCHER Empidonax minimus 1976/IJ

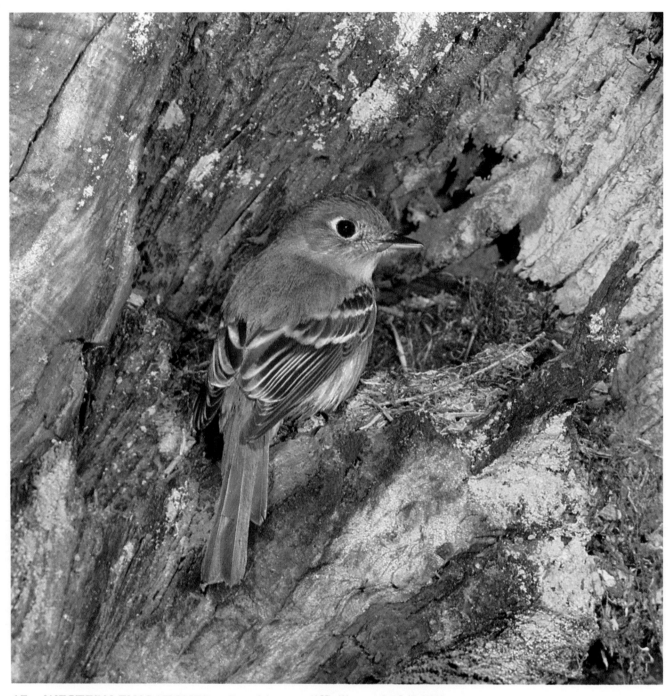

47 WESTERN FLYCATCHER Empidonax difficilis 1978/DEW

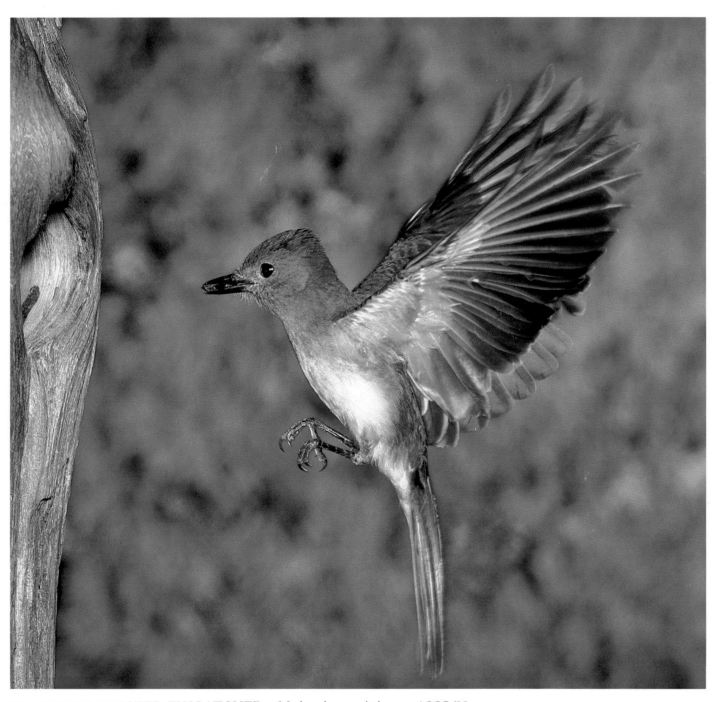

48 GREAT CRESTED FLYCATCHER Myiarchus crinitus 1982/IJ

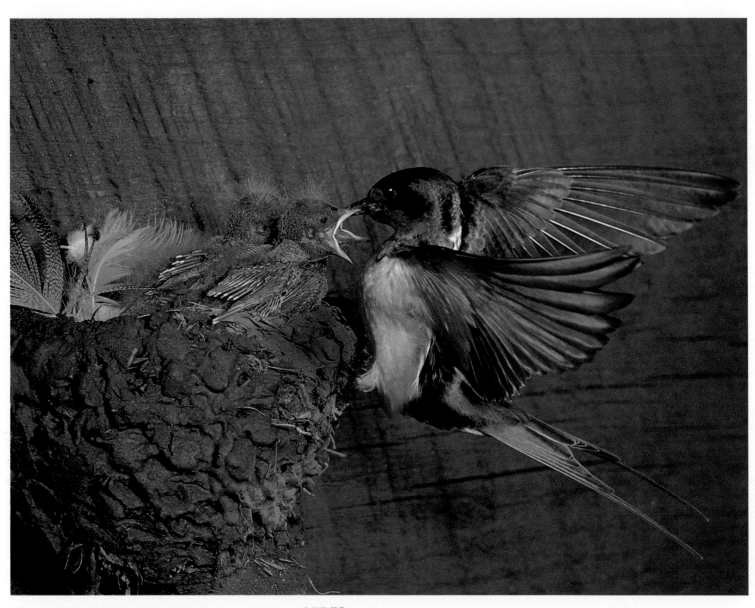

49 BARN SWALLOW Hirundo rustica 1977/IJ

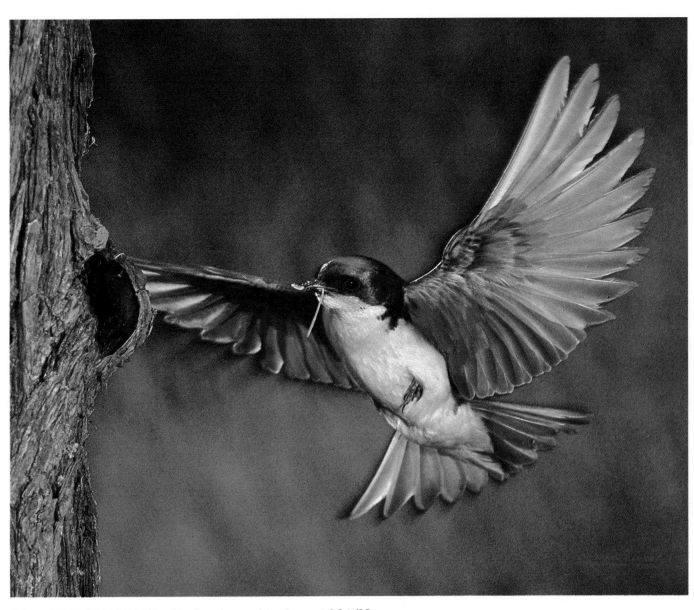

50 TREE SWALLOW Tachycineta bicolor 1981/IJ

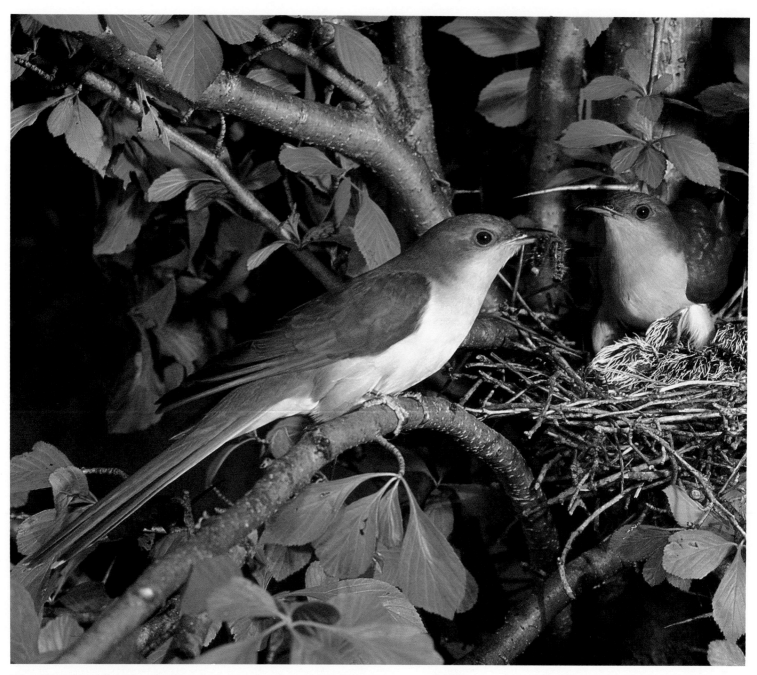

51 BLACK-BILLED CUCKOO Coccyzus erythropthalmus 1978/IJ

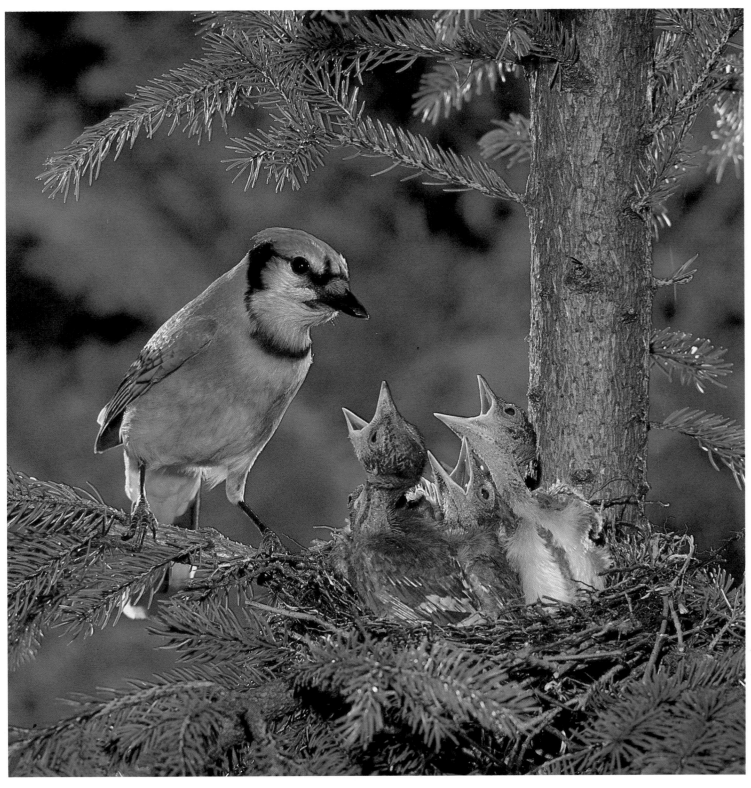

52 BLUE JAY Cyanocitta cristata 1979/IJ

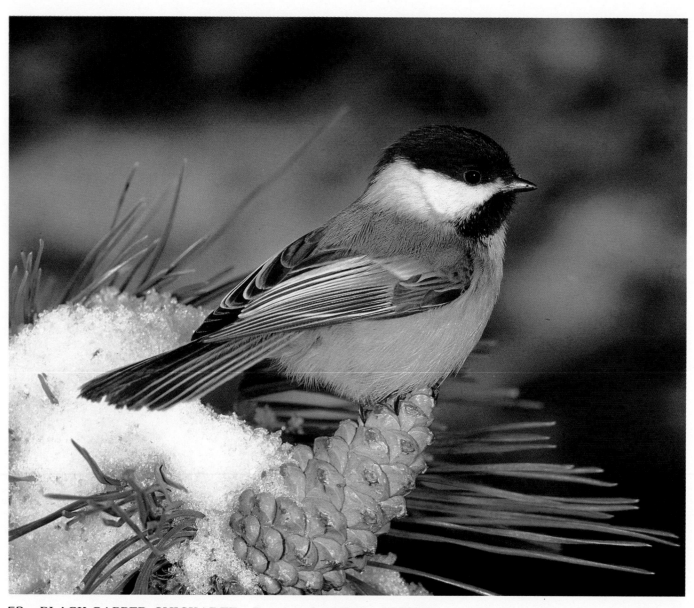

53 BLACK-CAPPED CHICKADEE Parus atricapillus 1982/IJ

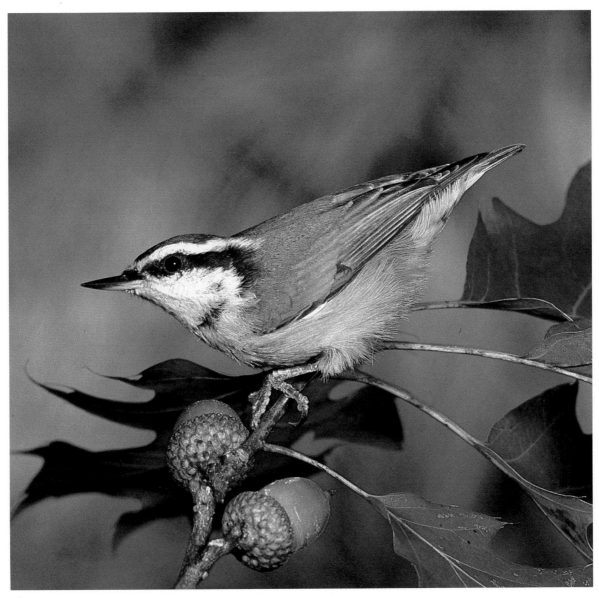

54 RED-BREASTED NUTHATCH Sitta canadensis 1981/IJ

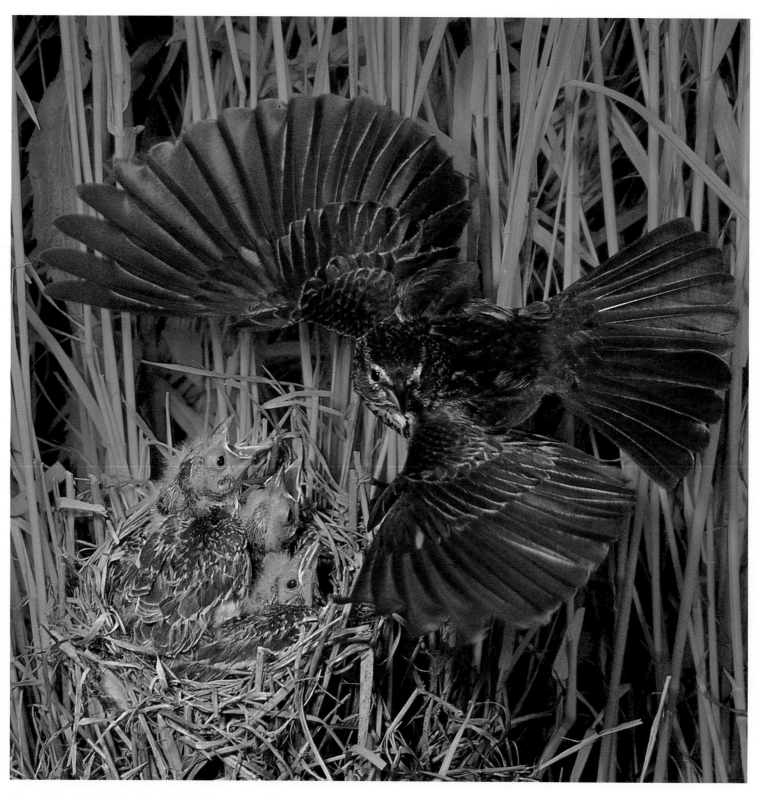

55 RED-WINGED BLACKBIRD Agelaius phoeniceus 1977/IJ

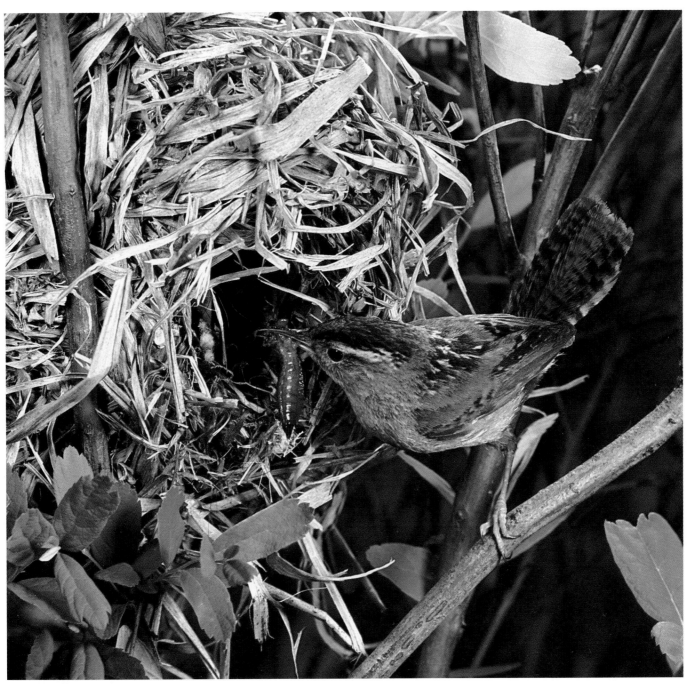

56 MARSH WREN *Cistothorus palustris* 1983/DEW

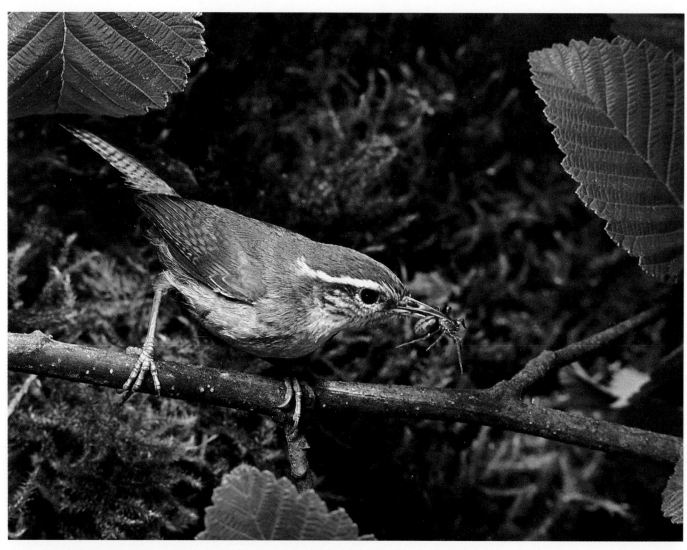

57　BEWICK'S WREN　Thryomanes bewickii　1983/SP

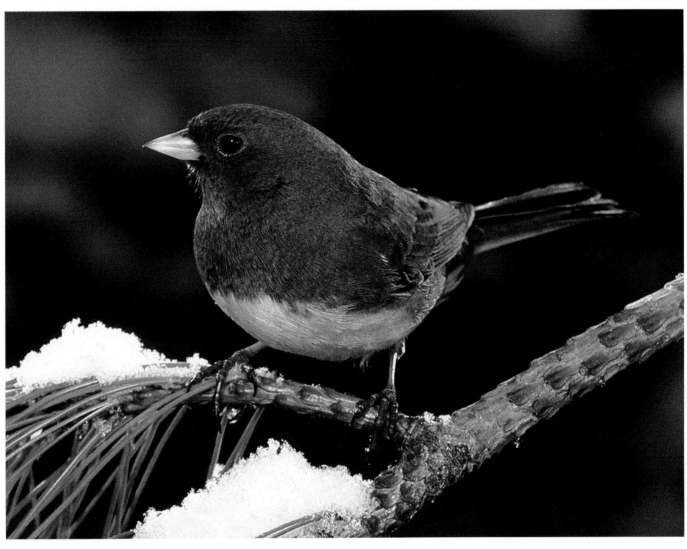

58 DARK-EYED JUNCO Junco hyemalis 1981/IJ

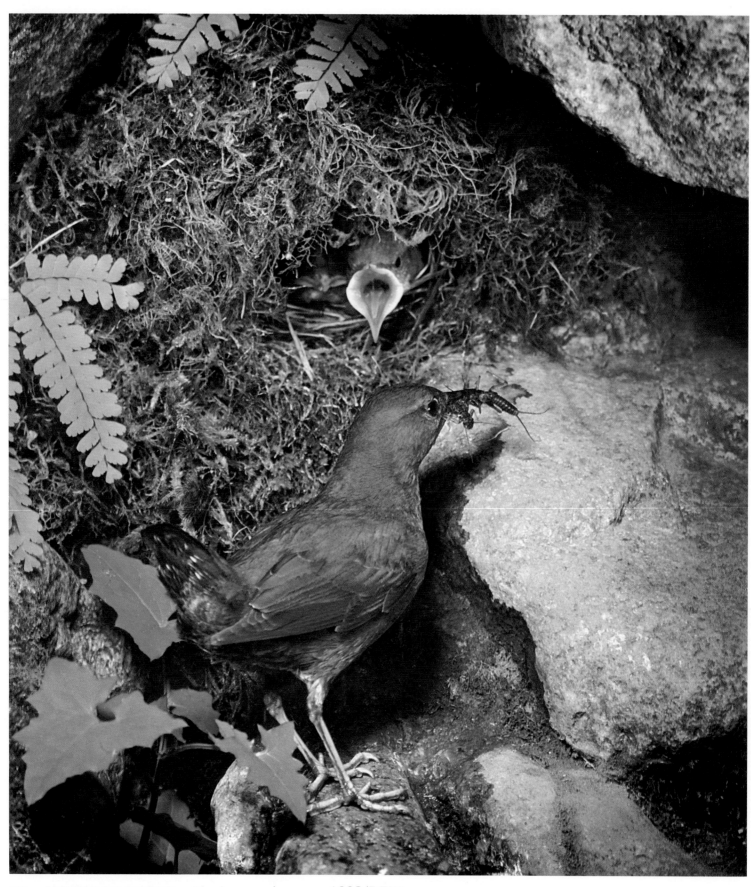

59 AMERICAN DIPPER Cinclus mexicanus 1982/DEW

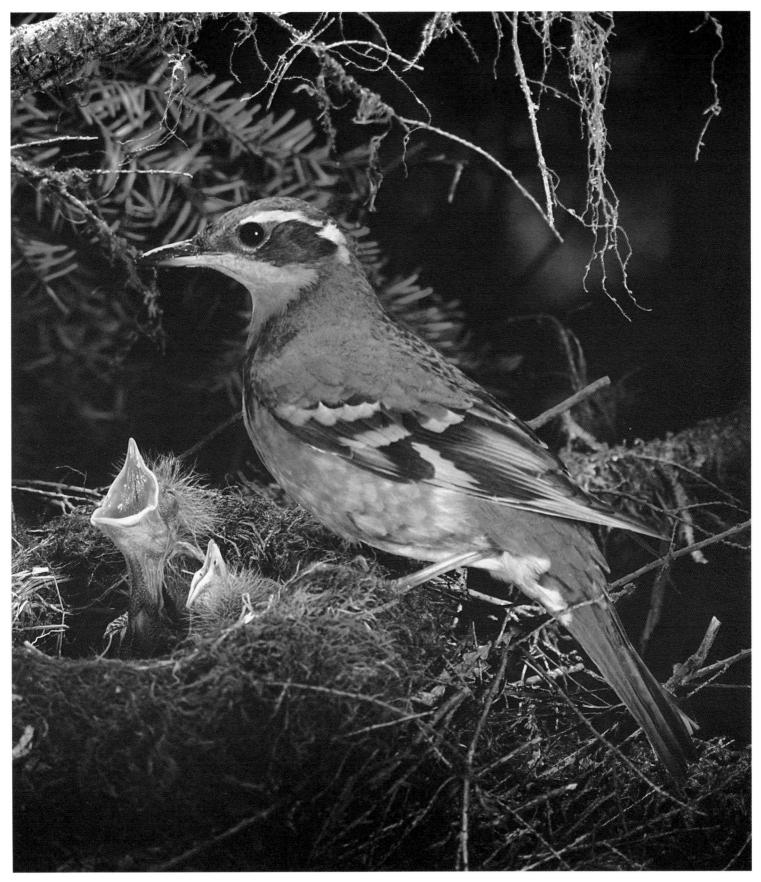

60 VARIED THRUSH Ixoreus naevius 1983/DEW

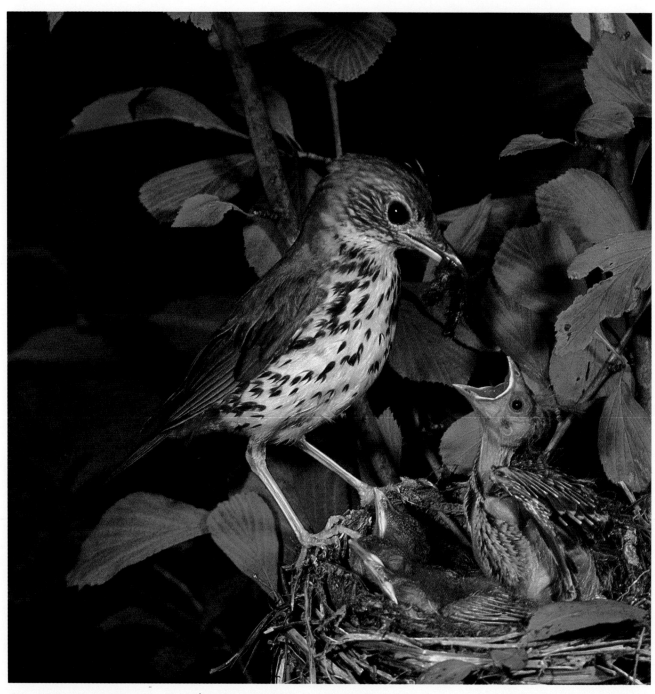

61 WOOD THRUSH Hylocichla mustelina 1978/IJ

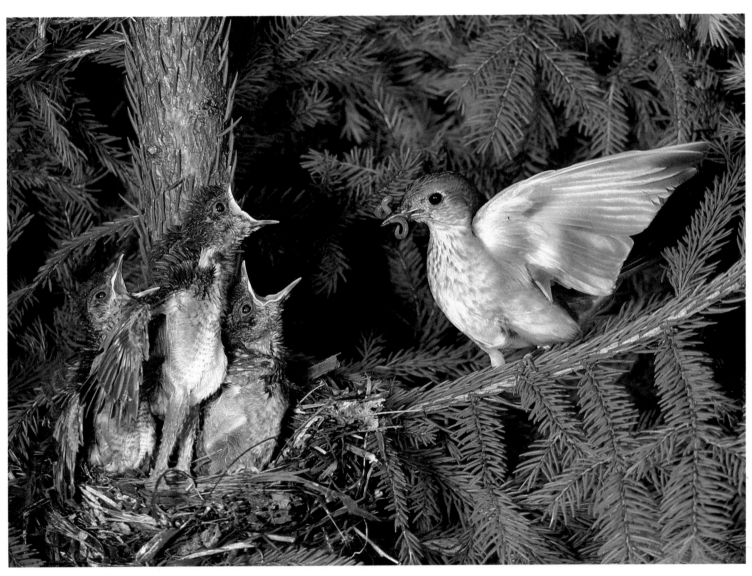

62 VEERY Catharus fuscescens 1981/IJ

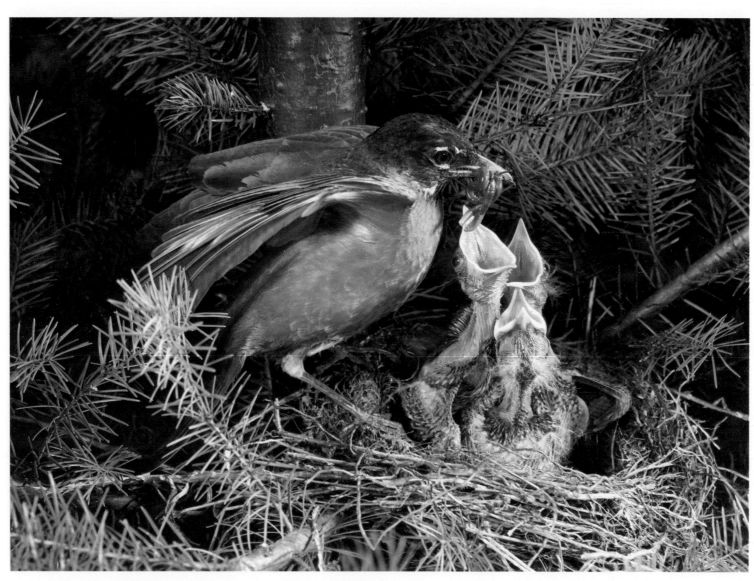

63 AMERICAN ROBIN Turdus migratorius 1983/SP

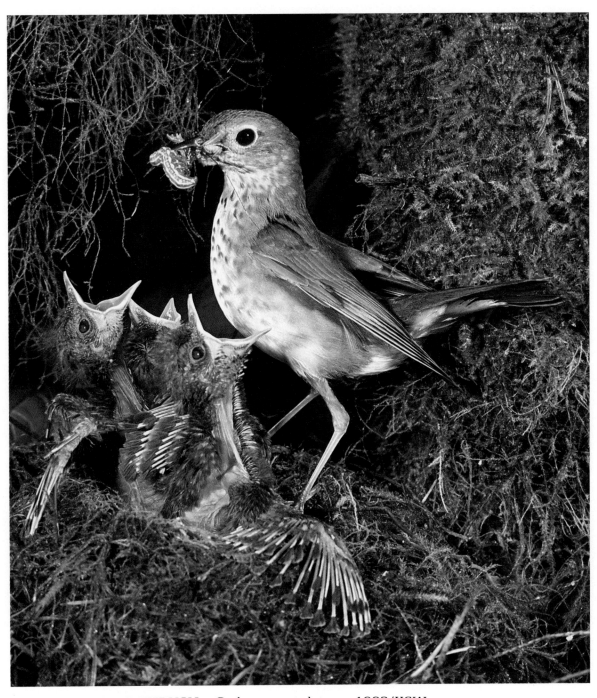

64 SWAINSON'S THRUSH Catharus ustulatus 1982/KSW

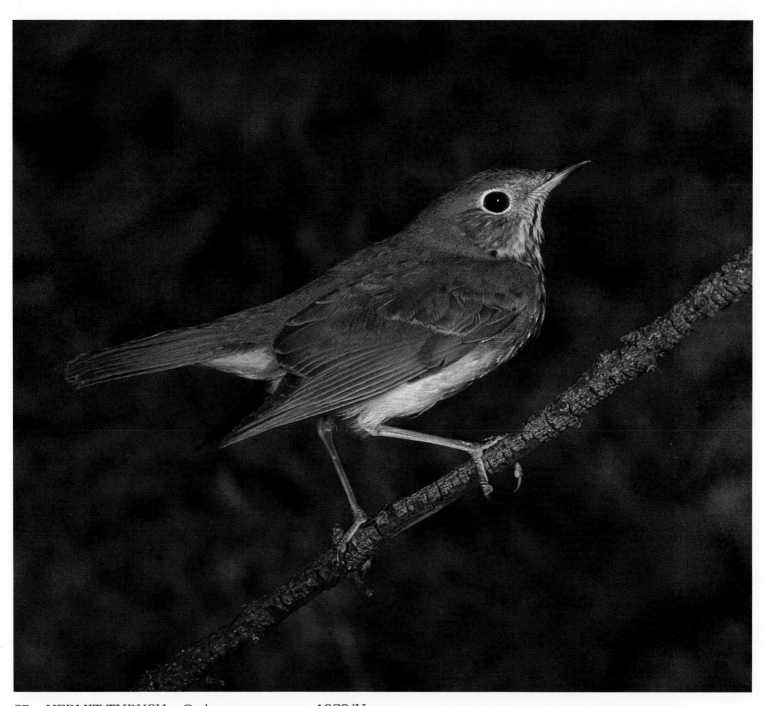

65 HERMIT THRUSH Catharus guttatus 1978/IJ

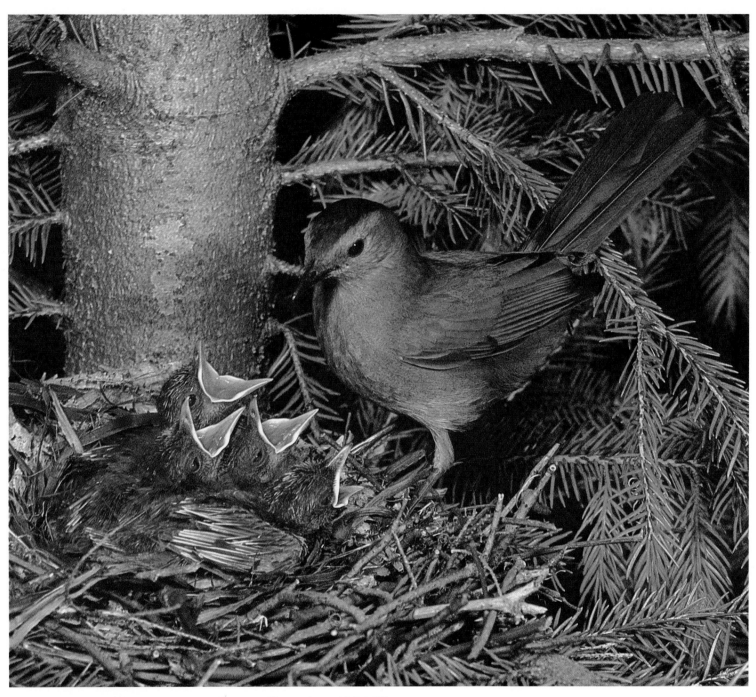

66 GRAY CATBIRD Dumetella carolinensis 1974/IJ

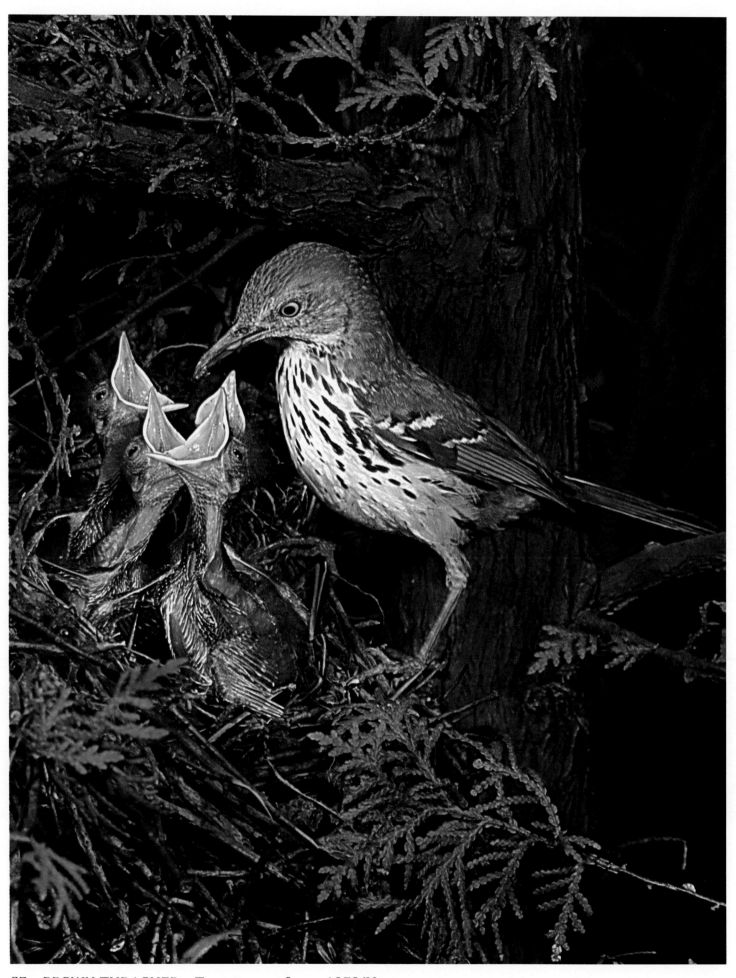

67 BROWN THRASHER Toxostoma rufum 1978/IJ

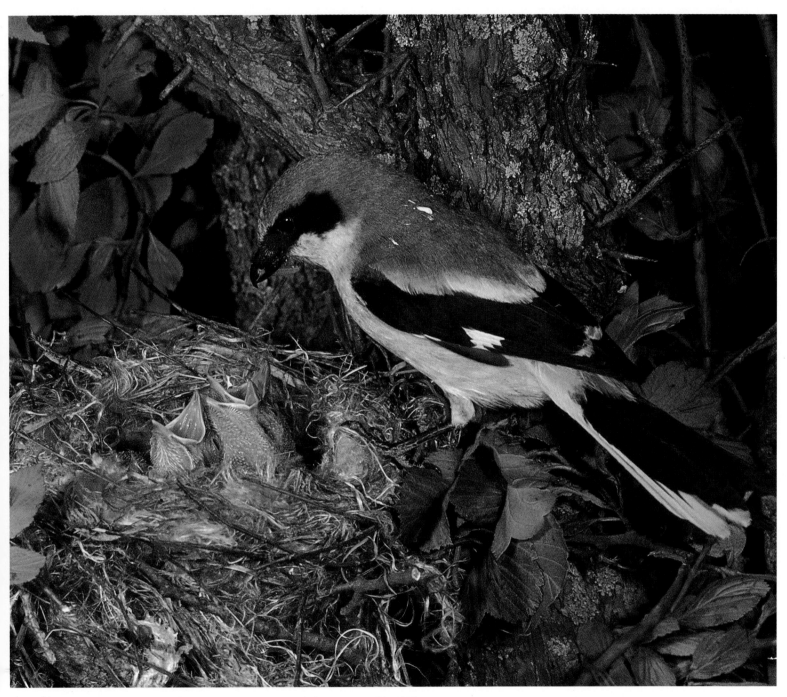

68 LOGGERHEAD SHRIKE Lanius ludovicianus 1977/IJ

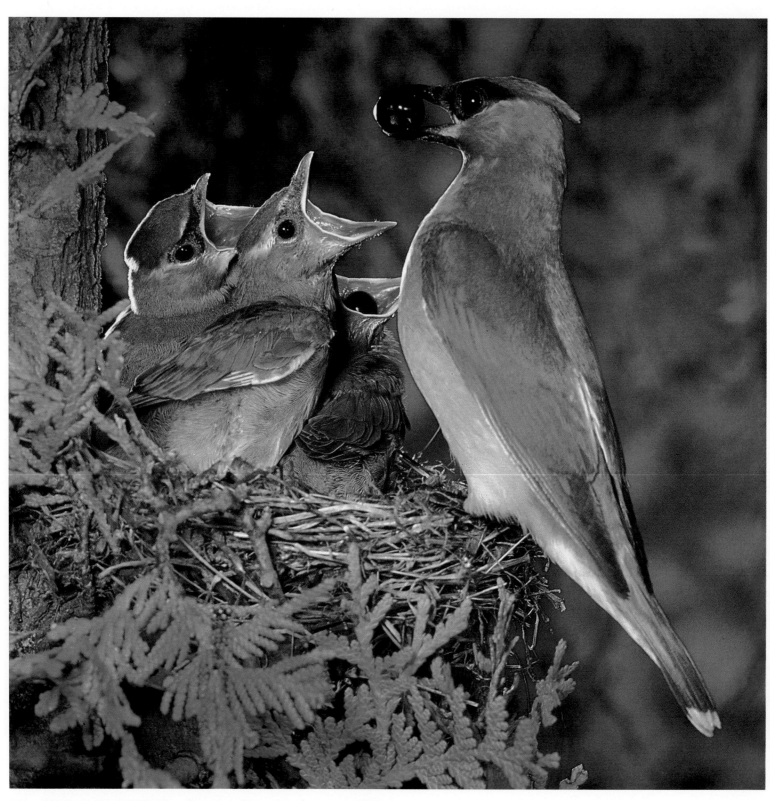

69 CEDAR WAXWING Bombycilla cedrorum 1977/IJ

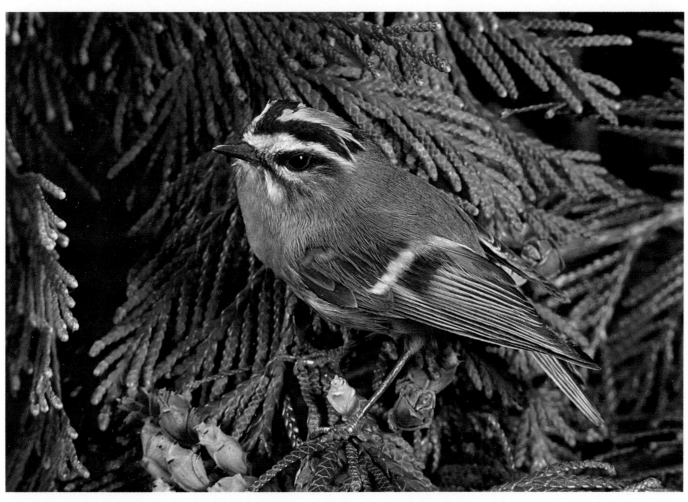

70 GOLDEN-CROWNED KINGLET Regulus satrapa 1982/DEW

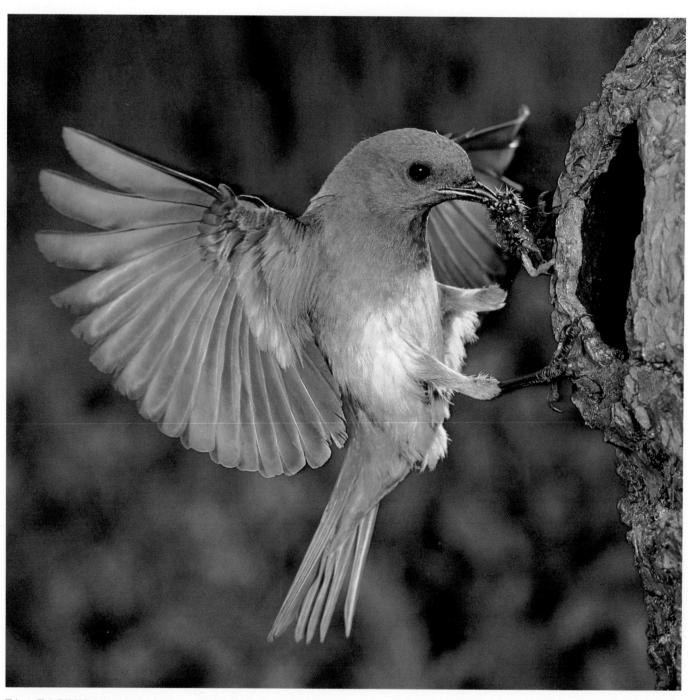

71 EASTERN BLUEBIRD Sialia šialis 1980/IJ

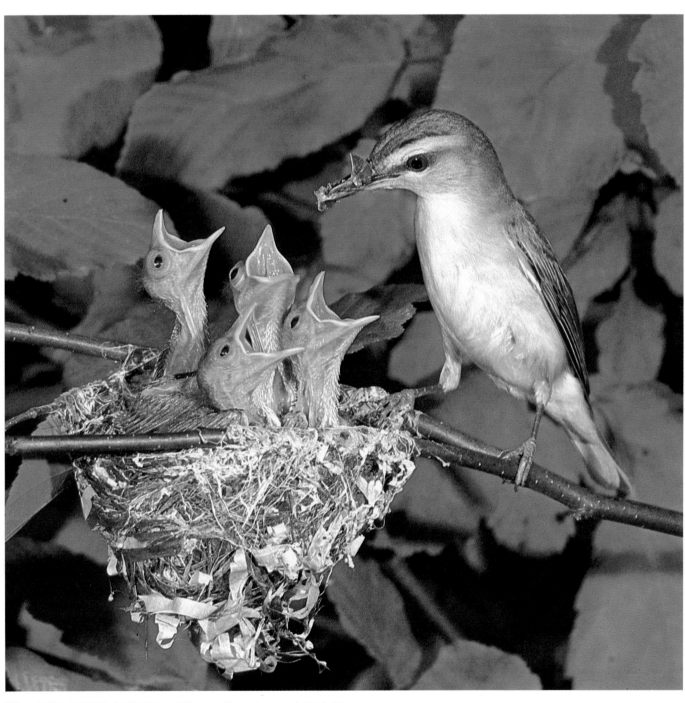

72 RED-EYED VIREO Vireo olivaceus 1980/IJ

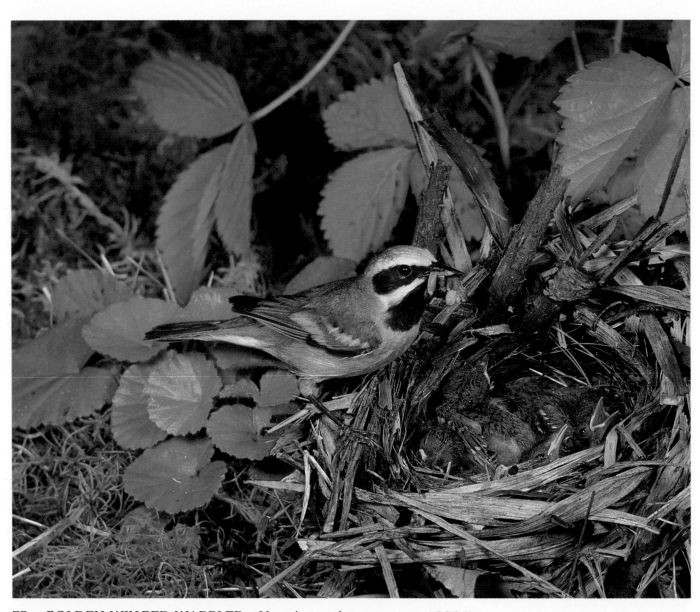

73 GOLDEN-WINGED WARBLER Vermivora chrysoptera 1982/IJ

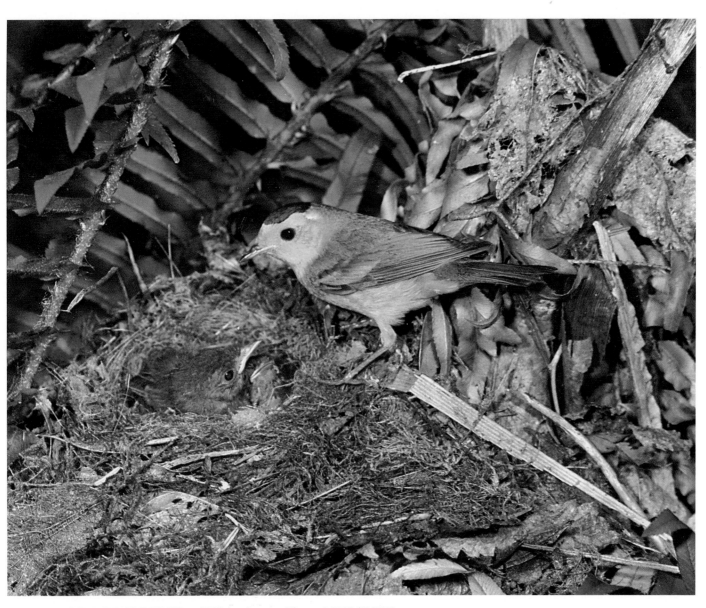

74 WILSON'S WARBLER Wilsonia pusilla 1979/DEW

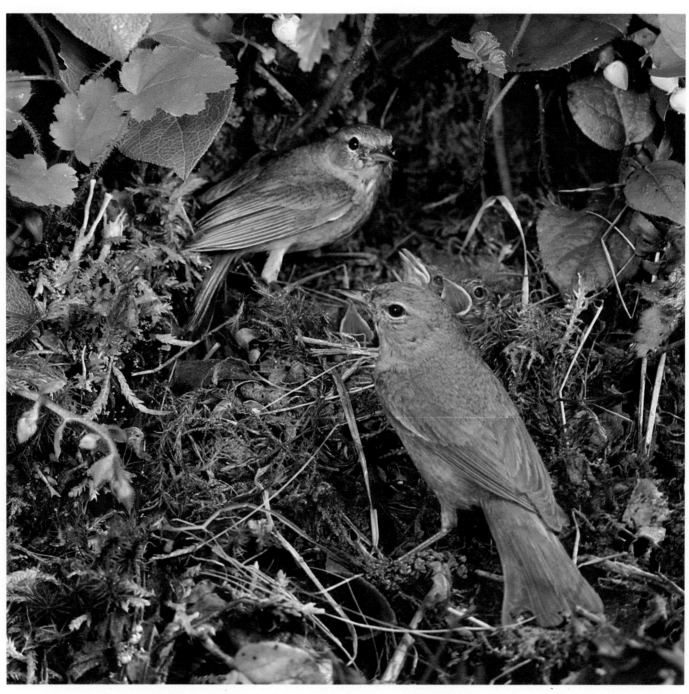

75 ORANGE-CROWNED WARBLER Vermivora celata 1983/DEW

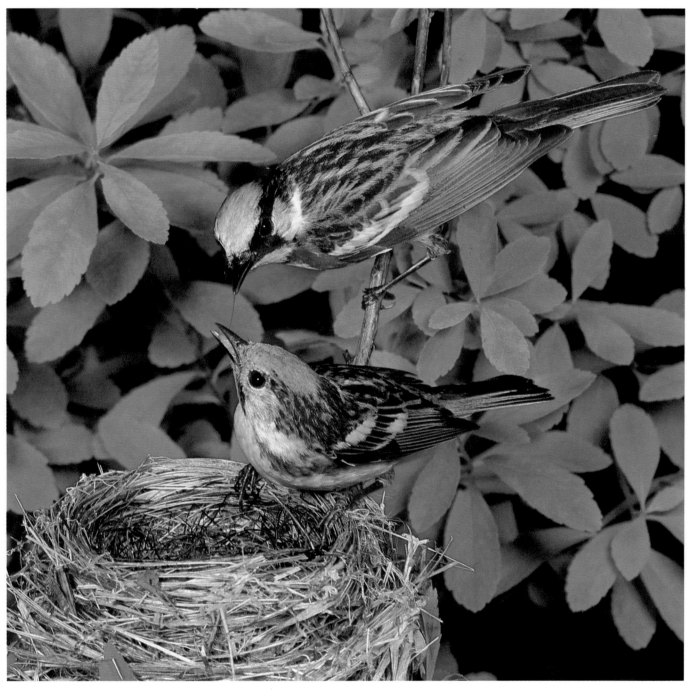

76 CHESTNUT-SIDED WARBLER Dendroica pensylvanica 1980/IJ

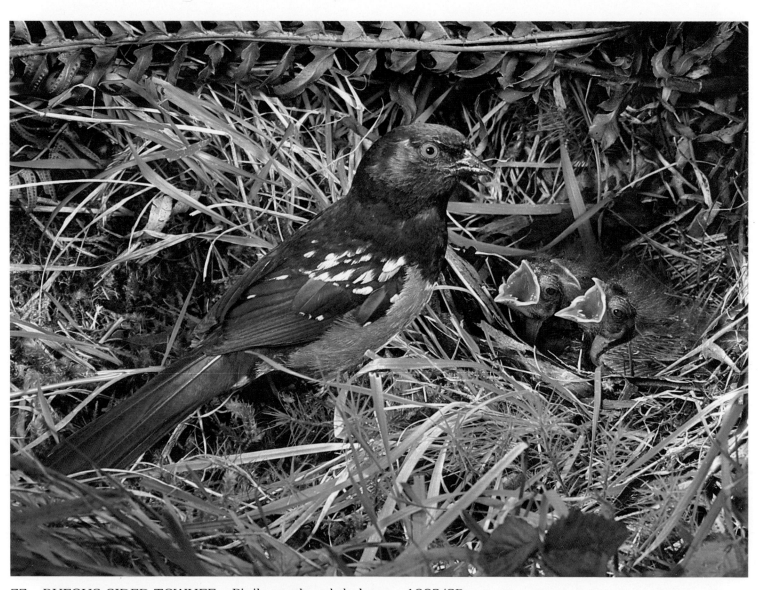

77 RUFOUS-SIDED TOWHEE Pipilo erythrophthalmus 1983/SP

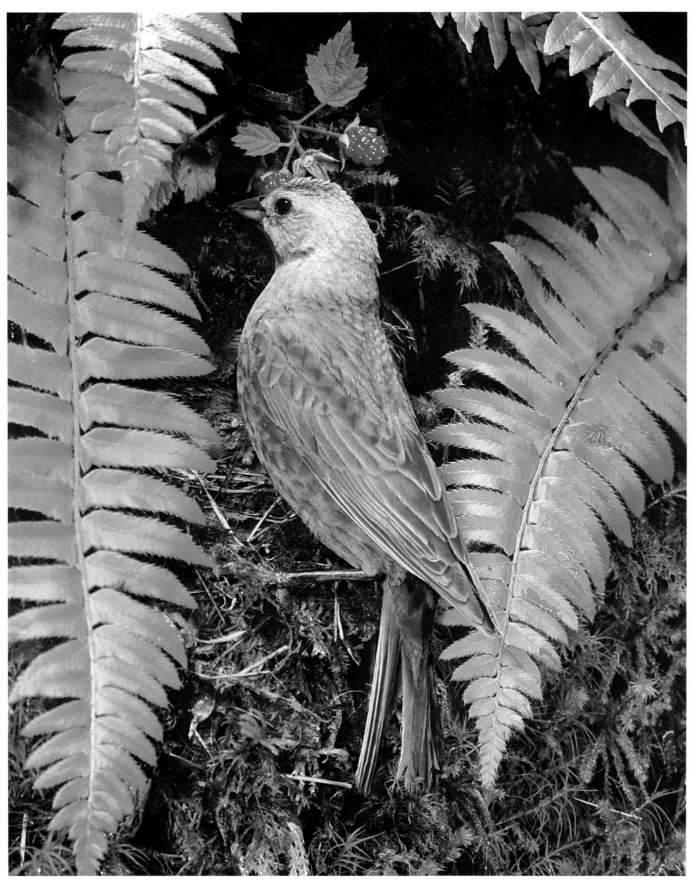

78 BROWN-HEADED COWBIRD Molothrus ater 1983/SP

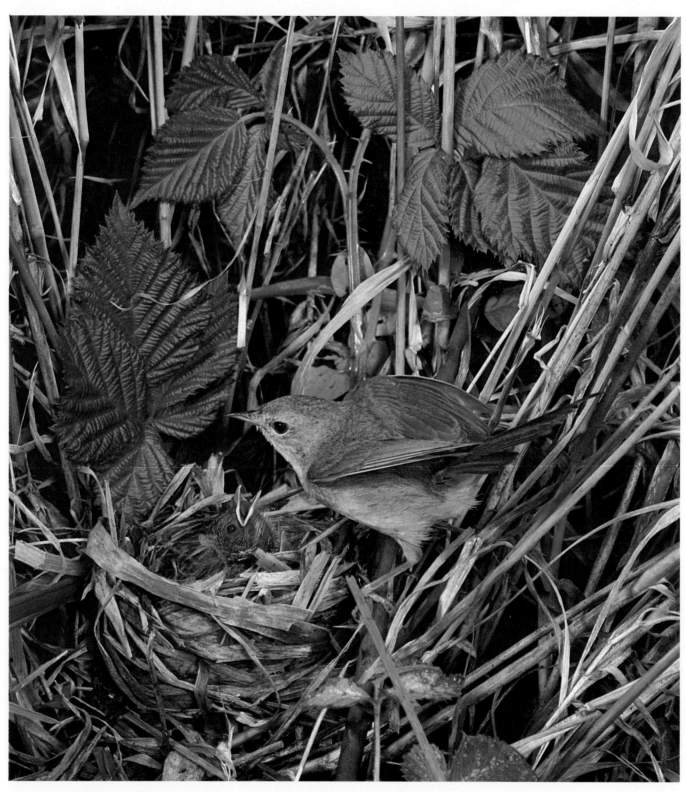

79 COMMON YELLOWTHROAT Geothlypis trichas 1981/DEW

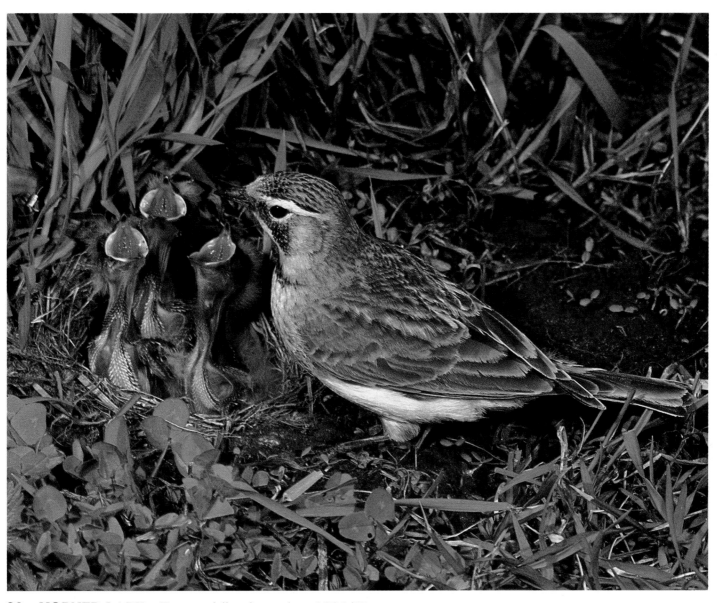

80 HORNED LARK Eremophila alpestris 1981/IJ

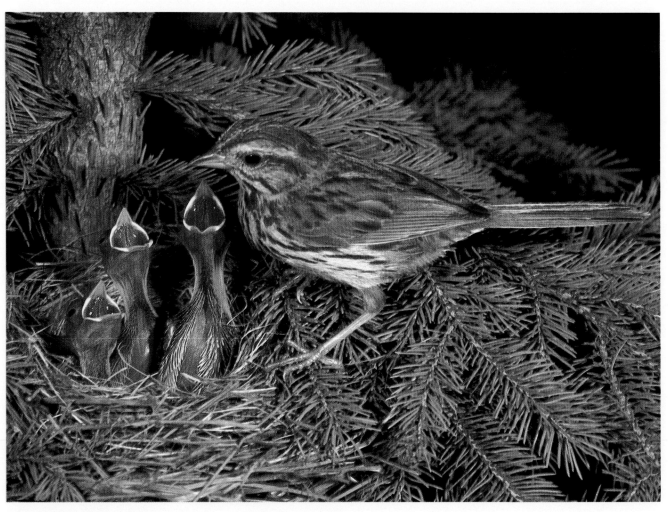

81 SONG SPARROW Melospiza melodia 1976/IJ

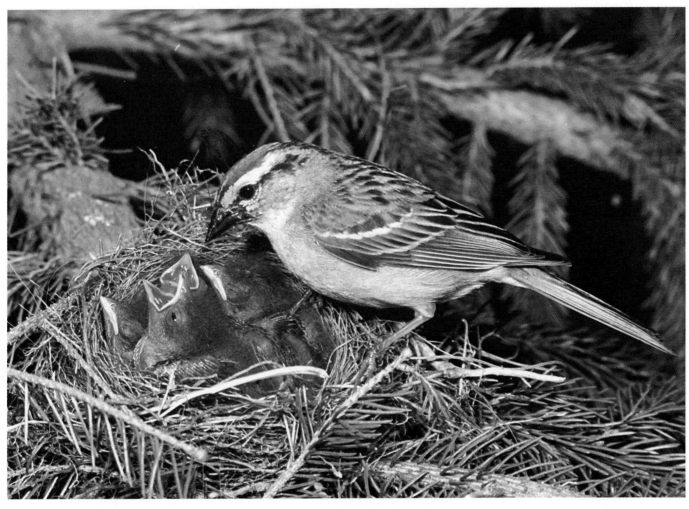

82 CHIPPING SPARROW Spizella passerina 1978/DEW

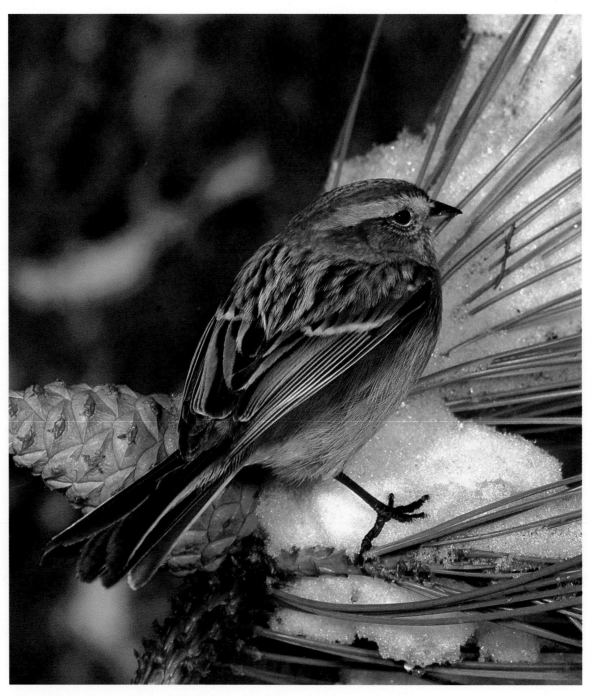

83 AMERICAN TREE SPARROW Spizella arborea 1982/IJ

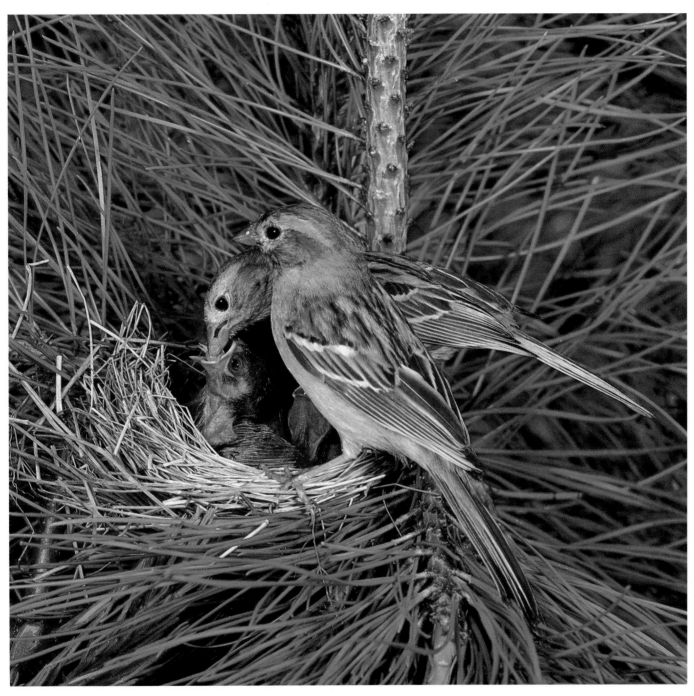

84 FIELD SPARROW Spizella pusilla 1982/IJ

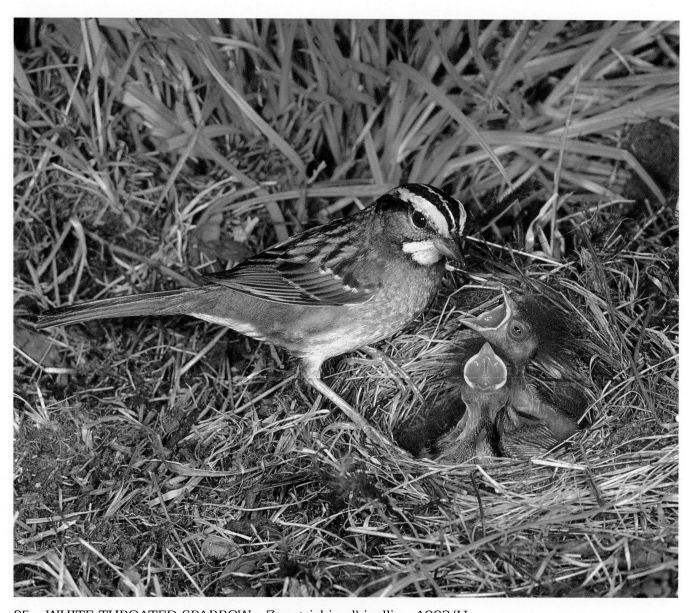

85 WHITE-THROATED SPARROW *Zonotrichia albicollis* 1982/IJ

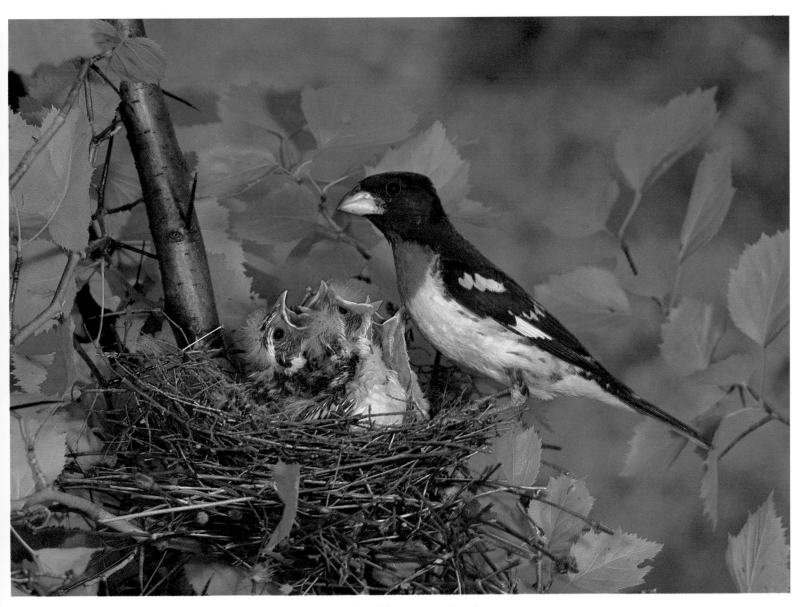

86 ROSE-BREASTED GROSBEAK Pheucticus ludovicianus 1979/IJ

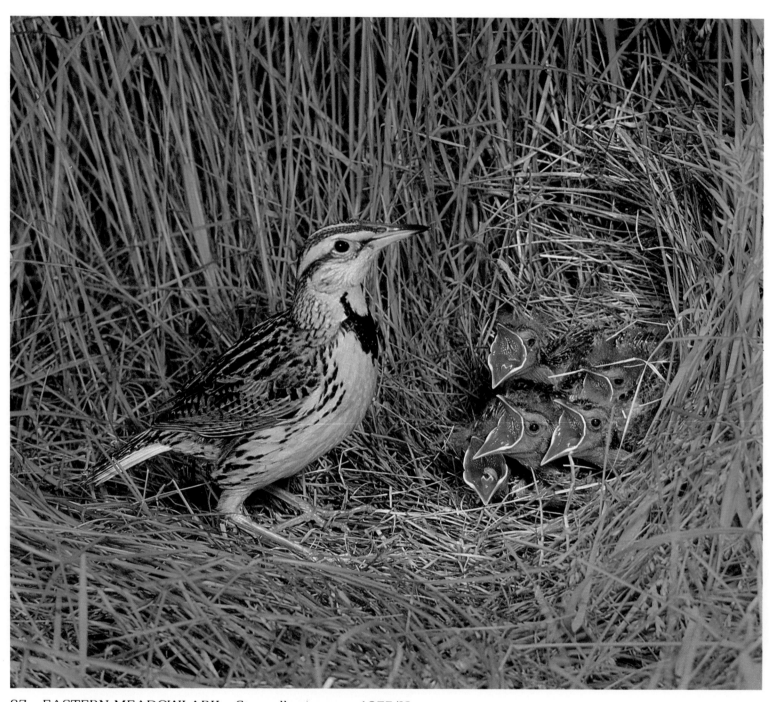

87 EASTERN MEADOWLARK Sturnella magna 1975/IJ

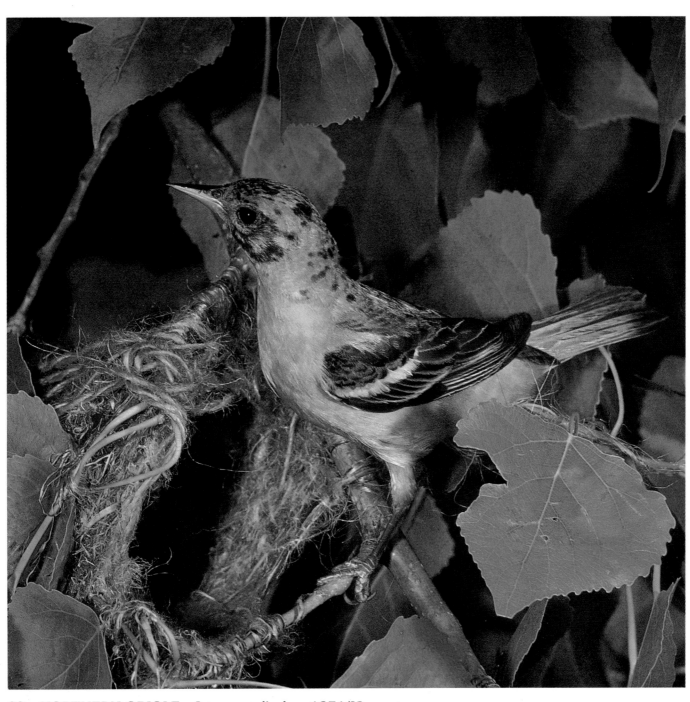

88 NORTHERN ORIOLE Icterus galbula 1974/IJ

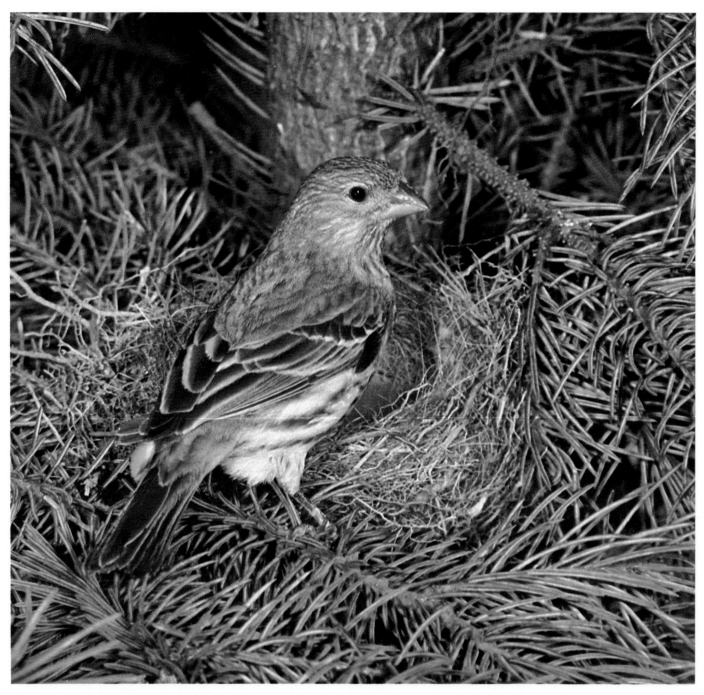

89 HOUSE FINCH Carpodacus mexicanus 1977/DEW

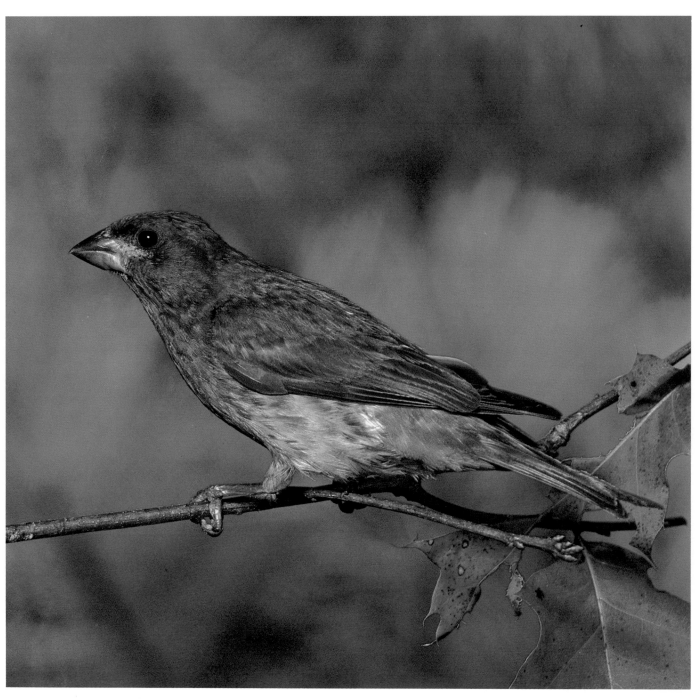

90 PURPLE FINCH Carpodacus purpureus 1979/IJ

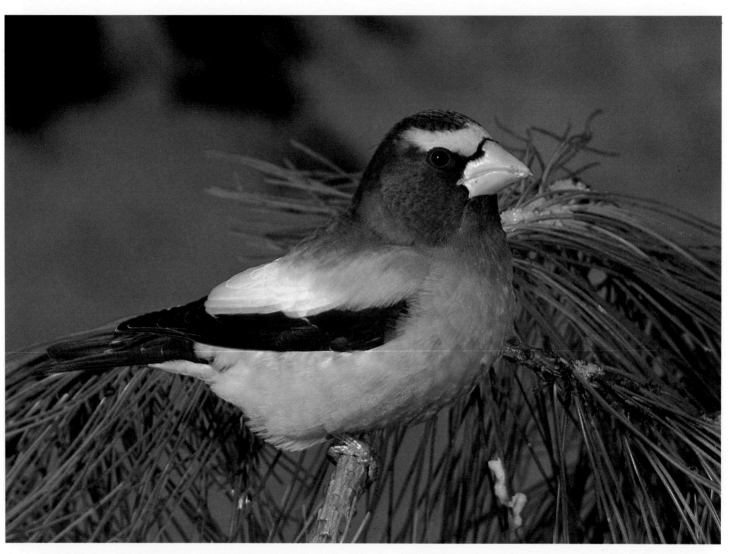

91 EVENING GROSBEAK Coccothraustes vespertinus 1979/IJ

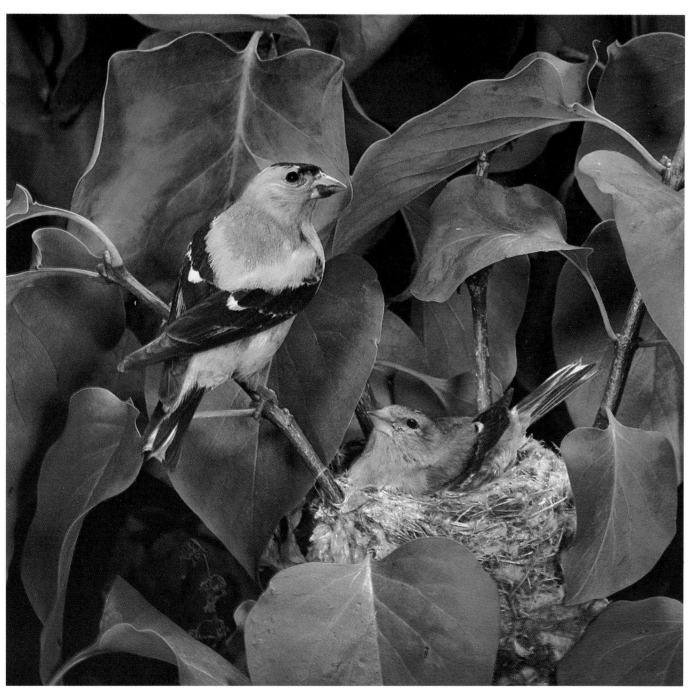

92 AMERICAN GOLDFINCH Carduelis tristis 1981/DEW

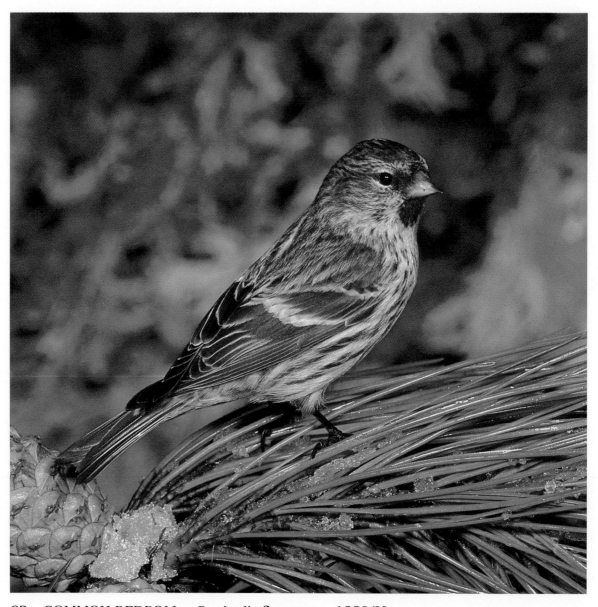

93 COMMON REDPOLL Carduelis flammea 1980/IJ

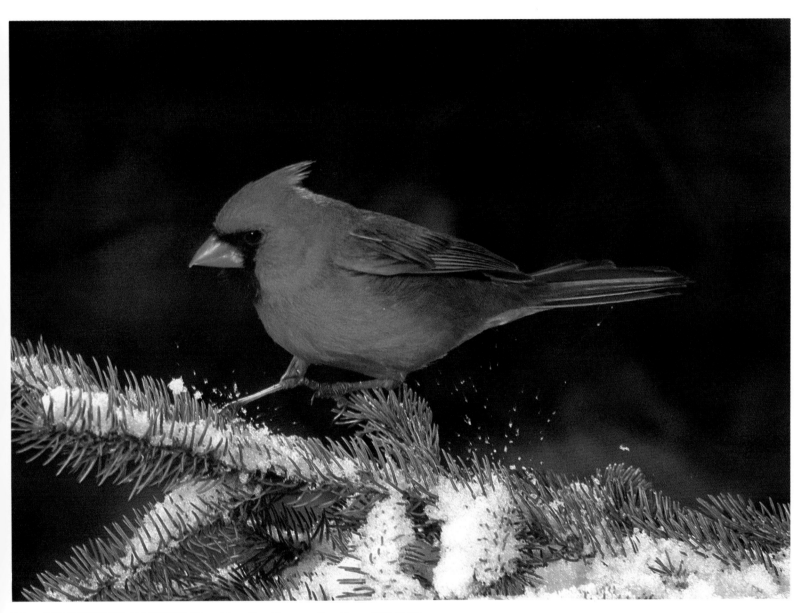

94 NORTHERN CARDINAL Cardinalis cardinalis 1978/IJ

Selected References

Dalton, Stephen. *Caught in Motion High-Speed Nature Photography.* New York: Van Nostrand Reinhold Company Inc., 1982.

Godfrey, W. Earl. *The Birds of Canada.* Ottawa: National Museums of Canada, 1979.

Hosking, Eric. *Eric Hosking's Birds Fifty Years of Photographing Wildlife.* London, Eng: Pelham Books, 1979.

National Geographic Society. *Field Guide to the Birds of North America.* Washington, D.C., 1983.

Porter, Eliot. *Birds of North America A Personal Selection.* New York: Chanticleer Press, 1972.